HAUNTED
ELLICOTT CITY

D1270562

HAUNTED
ELLICOTT CITY

SHELLEY DAVIES WYGANT

Haunted
America

Published by Haunted America
A Division of The History Press
Charleston, SC
www.historypress.com

Copyright © 2018 by Shelley Davies Wygant
All rights reserved

Front cover: R. Scott Kramer.
Back cover: Howard County Historical Society.

First published 2018

Manufactured in the United States

ISBN 9781467138116

Library of Congress Control Number: 2018942427

Notice: The information in this book is true and complete to the best of our knowledge. It is offered without guarantee on the part of the author or The History Press. The author and The History Press disclaim all liability in connection with the use of this book.

All rights reserved. No part of this book may be reproduced or transmitted in any form whatsoever without prior written permission from the publisher except in the case of brief quotations embodied in critical articles and reviews.

Dedicated to the ghosts of Ellicott City. Past, present…and future.

A great combination of local history, local legends, and scary ghost stories. Read it, just not late at night!
—Paulette Lutz, past president, officer and board member, Howard County Historical Society

This deft combination of old Ellicott City ghost stories and their historical background makes for compelling reading for the history buffs and ghost story fans alike!
—Gretchen Shuey, owner, Bean Hollow

Explore the past in this fascinating mix of history and spirits. A must read for anyone interested in Historic Ellicott City.
—Stephanie Edner, founder, Oella Paranormal

This latest accounting of our undead reveals old legends, some less well-known tales and interesting historical facts as well. I doubt that readers will ever feel the same as they walk, or even drive, through town. I suspect they'll be looking over their shoulders and in their rearview mirrors!
—Ed Lilley, local history buff

CONTENTS

CONTENTS

ACKNOWLEDGEMENTS

As someone who has fallen deeply in love with the history of Ellicott City and believes in ghosts just enough not to fool with them, I jumped at the chance to research and write about the places where those two interests intersect. Today, I'm thrilled to let you in on what I've learned about almost three dozen of the town's most haunted sites in a book that reveals forgotten history, lost legends, never-before-told ghost stories and eyewitness accounts of chilling paranormal investigations. It could not have been written without the help of some very special people and organizations.

I wish to thank all of the authors of past books and articles on the supernatural, individual tellers of tales of encounters with ghosts and all other sources of accounts of the spirit world that I have drawn upon to create this comprehensive compilation of ghost stories that have floated around since the earliest days of Ellicott City.

Thanks to Jeffrey Wygant, my husband, best friend and unfailing supporter of all my odd and inspired adventures; Ed Lilley, the unofficial "Mayor" of Ellicott City, who shared his stories and library of supernatural resources with me; Paulette Lutz, expert researcher at the Howard County Historical Society; and Shawn Gladden, executive director of the Howard County Historical Society, who graciously granted all my requests for otherworldly historical information.

Thanks also to Kyra Mitchell, my ace editor and eagle-eyed proofreader.

Thanks to the Howard County Historical Society, with its treasure trove of old photographs and historical information, and to all the generous

ACKNOWLEDGEMENTS

contributors of experiences and photographs and fact checking and scanning skills, including Dale Gardner, Gretchen Shuey, Judy Draper Perrine, Anne Schoenhut, Karen Griffith and Barbara Feaga.

INTRODUCTION

ORIGINALLY KNOWN AS ELLICOTT'S MILLS, the historic town of Ellicott City lies in a narrow granite ravine carved out by thousands of years of water from the Tiber Branch rushing down to the Patapsco River, which alternately murmurs and rages at her feet.

Paranormal experts say this combination of electrical charge that accumulates in granite deposits (which can hold and release information such as an event in history) and the presence of moving water (said to attract and energize spirits) explains why the town is an epicenter of supernatural activity. They refer to Ellicott City as a "thin place" where the veil between this world and the next is fine enough for people and beings to easily pass back and forth.

The presence of moving water certainly attracted and energized the three Quaker brothers, Joseph, Andrew and John, from Bucks County, Pennsylvania, who built their first mill on the Patapsco in 1772. Here in "this wild place, the Hollow," as Martha Ellicott Tyson described it in her book *Settlement of Ellicott's Mills*, they found the water power and fertile farmland they needed to make their mill—and the town they founded—a success.

Whether due to its connection to the spiritual world or its geographical location, the relatively tiny 325-acre historic district is, and has been, home an astonishing number and variety of houses of worship. The citizens of the town frequently needed the comfort of their faith communities. Nearly a dozen serious floods have brought death and destruction to Ellicott City since its founding beginning in 1780. Fortunately, no one was killed in that

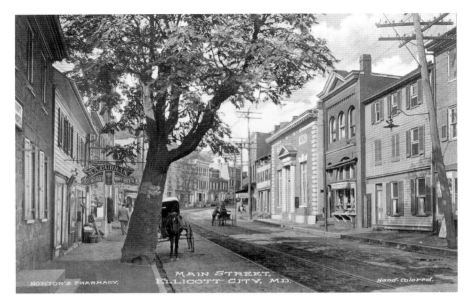

A 1910 view of Old Frederick Turnpike, now known as Main Street, Ellicott City, Maryland. *Library of Congress Historic American Buildings Survey.*

first recorded flood, but eighty-eight years later, on July 24, 1868, at least thirty-nine people living near the mill weren't so lucky. More recently, three especially devastating floods, the Hurricane Agnes flood of 1972 and the flash floods of 2016 and 2018, brought additional waves of death and destruction. The flood of 2016 was followed 666 days later by an even more catastrophic flash flood on May 27, 2018. In addition to destroying the town a second time, obliterating the original 1840 stone courthouse and claiming the life of National Guardsman Sergeant Eddison Herman, who slipped into the roaring rapids of the Tiber River while attempting to save another, this most recent flood may finally succeed in turning this vibrant, historical village into an actual ghost town.

Water isn't the only angel of death that carried souls away from Ellicott City. The town has also been ravaged by fierce fires that have periodically laid waste to swaths of buildings on Main Street and damaged or destroyed some of the town's most prominent buildings. With its continuous calamities plus the sometimes-violent departures of souls from all over the county, it's no wonder this tiny hamlet on the Patapsco has easily supported the services of at least seven funeral parlors.

INTRODUCTION

As you'll discover in the pages of this comprehensive collection of the history and ghost stories of Ellicott City's most haunted places, many of our ghosts, whether mischievous or malevolent, just want to be noticed. Some are trapped in the twilight by their reluctance to cross over. Others make their presence known because they want something in death that eluded them in life. And a few, perhaps driven by evil or loneliness, seem to be determined to lure the living into joining them on the other side of the thin veil that separates the here and now from the hereafter. Despite other cities' claims to the distinction, based on even the roughest calculation of the number of ghosts per square foot, Ellicott City is the Most Haunted Town in America.

PART I

MANIFESTATIONS ON MAIN STREET

B&O Railroad Station Museum

TRAINS COME AND GO, BUT THE SPIRITS NEVER LEAVE.

TRAINS AND TRAVELING ARE VERY powerful presences and metaphors in both the physical and metaphysical world. Over the past nearly two centuries, thousands of passengers have come through the Baltimore & Ohio Railroad Station at Ellicott's Mills on their way to the city or points west. Some unfortunate souls have made the station their last stop by meeting their deaths on or near the adjacent railroad tracks. Most accounts of these travels and tragedies have been lost in the mists of history, but continued reports of strange happenings keep the connection to the past fresh in the minds of the community.

The History

Completed in 1831, the sturdy, two-story, granite B&O Railroad Station building at 3711 Maryland Avenue is the first and oldest commercial railroad station terminus in the United States. It was built as the ending point for the first thirteen miles of commercial railroad track that ran between Baltimore and Ellicott's Mills.

Originally, the south end of the station was a garage area where the steam engines could be repaired. The center section was devoted to storing freight. The north part was the station agent's office. Before 1857, passengers bought their tickets and relaxed at the nearby Patapsco Hotel and then walked over the Oliver Viaduct to catch their train.

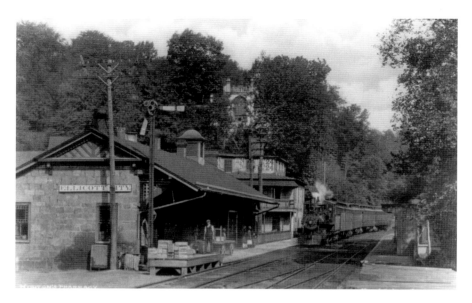

Baltimore & Ohio Railroad Ellicott Mills Station, built in 1830 as the first railroad terminus in the country. *Howard County Historical Society.*

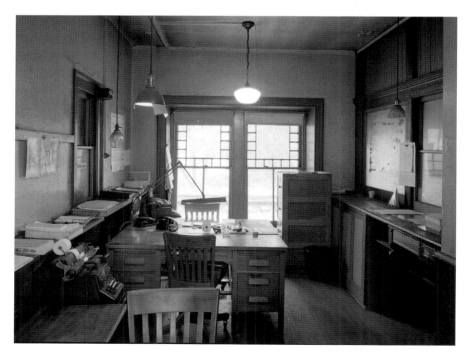

Station agent's office at the Ellicott Mills Station. *Library of Congress Historic American Buildings Survey.*

In the mid-1800s, the station was remodeled. The freight area was turned into passenger waiting rooms, one for women and children and one for men. Sometime in the 1860s, a turntable was installed. Later, in 1885, E. Francis Baldwin designed the brick freight house at the south end of the station.

Passengers continued riding the rails until the 1950s, although by 1928, only three trains left Baltimore on the line each day. Freight service continued until the early 1970s. In 1972, Hurricane Agnes took out the B&O Railroad's Old Main Line, and the tracks were unused for many years until CSX began running freight trains through the town again. As of this publication, freight trains regularly rumble past the old station, which is now used as a museum.

The Haunting

From the deaths of hundreds who have been struck and killed by trains over the years to the heartbreaking loss of two teenaged girls who were crushed by tons of coal during a train derailment in 2012, the B&O Railroad Station has been the site of many arrivals and departures in this world and the next.

Anyone in Ellicott City who knows anyone who has worked at the B&O Railroad Station Museum has heard the stories. People working alone in the offices on the ground floor talk about the scraping and shuffling sounds of ghostly freight being moved around on the upper floor of the building. Newcomers rush up to find out what's happening. Old-timers just shrug and get back to what they were doing.

Of course, not every haunting is the result of a death. Some are simply "recordings" of past events that keep being replayed and picked up by the living who are open to listening.

During one of the station's Civil War programs, a group of Union reenactors were staying overnight in the station. One of the participants couldn't sleep, so he went outside and sat on the steps of the station. While he was there, another man in military garb, who he thought was a Union reenactor, came up to him. He didn't recognize him but assumed that he was friends with someone else in the group. They chatted for a minute or two, then the man said he had to go. As he was walking away, the reenactor called after him, "Hey, aren't you going back to the station?" At that very moment, the man disappeared, vanishing into the mists rising from the Patapsco River.

The next morning, the reenactor looked around for the man he'd spoken with the night before. He described the man to his fellow reenactors and

Passenger waiting room at the Ellicott Mills Station, where disturbing sounds are heard. *Library of Congress Historic American Buildings Survey*.

asked if they had invited him or knew where he was. No one recognized the other man by his description. When he talked with the station managers, he learned that the number of participants was exactly the same that had signed up to be there both inside and out. Everyone was accounted for, except the vanished Union soldier.

Trains have likely claimed hundreds of lives since the tracks were first laid in the 1830s. There's no reason to believe that they won't claim more. Perhaps the ghosts of the unfortunate victims of these railroad tragedies linger on to warn the living about the dangers of tempting fate and these hurtling engines of death.

2

THE RAILROAD HOTEL

A REFUGE FOR AN ESCAPED CONFEDERATE PRISONER WHO MAY HAVE MANAGED TO OUTRUN DEATH.

ALTHOUGH THE BUILDING IS PLAIN and unremarkable, hidden behind the silent stone face of 8030, 8032 and 8034 Main Street is a treasure trove of secrets. The first account involves little-known stories of Ellicott City's bustling days as a commercial hub. The second is a haunting that may be an eternal replay of a Civil War–era murder that continues to reverberate today.

THE HISTORY

Constructed between 1832 and 1847 by Andrew McLaughlin on land he purchased from Andrew and John Ellicott, this four-story granite block structure was built as a hotel to house railroad workers. The building was originally partitioned into eighteen individual rooms, each with its own fireplace. The halls were narrow, as were the twenty-six-inch-wide staircases at each side of the building.

The earliest written record is an indenture dated November 6, 1847, from the Granite Manufacturing Company to Thomas Wilson that also mentions an old right-of-way for wagons and stagecoaches to bring supplies and mail to the establishment.

After the end of the Civil War, the building seemed to be used for retail commercial purposes. A lease dated May 16, 1877, shows that Thomas

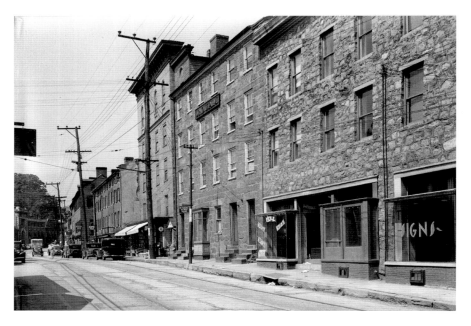

The Railroad Hotel (*third building from right*) and the Town Hall (*fourth from right*). *Library of Congress Historic American Buildings Survey.*

Wilson rented a shop to Prussian "confectioner" Albert Hermes for fifteen dollars a month.

Wilson died in 1879, and the building, along with the Patapsco Hotel next door, was sold to Thomas Hunt in 1881 for $4,000. The Railroad Hotel remained in the Hunt family until their trustee conveyed the hotel to Edwin Rodey on September 6, 1912. The next year, Rodey sold the building to a charitable social organization called Howard County Forty-Six, Junior Order United American Mechanics of Howard County for $3,000.

The Mechanics organization held on to the building through most of the twentieth century, selling it to a Mr. and Mrs. John Baker in 1960. In 1972, Mr. and Mrs. Thomas Cate bought the property. They turned around and sold it to John and Mary Swan in March 1973. The Swans owned it until 1985, when they sold it to the 8030 Main Street Partnership for $215,000. The partnership later sold the 5,248-square-foot building to ECH LLC in 2002 for $325,000.

Over its nearly two hundred years on Main Street, the building has been home to dozens of businesses and organizations. Among them are Turn Over a New Leaf, the Meeting House, Caryl Maxwell Ballet, New

Covenant Faith Fellowship, Upper Room, ZeBop, Randoph C. Ruckert Accountants, Concatentions, Automotive Publications, the Garden Creative, Affairs Remembered, Cima Talent, Lamp & Gift, Summer of Love and many others.

THE HAUNTING

The story begins and ends in darkness one night during the years when the Civil War was ripping the country apart along the seams of Maryland's western and northern borders.

It's said that on this night, a young Confederate soldier escaped from the custody of Union troops guarding the Thomas Viaduct in Elkridge. After sneaking away, he slipped into the inky blackness of the woods of what is now the Patapsco State Park and made his way down the railroad tracks.

Lost and disoriented, he decided to follow the tracks, hoping that they led south toward Washington, D.C., and back toward home. Unfortunately for him, they didn't. The tracks the escaped Confederate ran along for miles and miles ran straight into Ellicott City.

When the lights of the town came into view, he was horrified. He recognized the skyline from earlier in the week, when he had been transported through it by train from western Maryland, where he'd been captured.

His horror was completely justified. The town was home to the Patapsco Guard and a provost marshall's office, so Union soldiers were everywhere. He stumbled into town along Maryland Avenue near the B&O Railroad Station's freight house and slipped into Tiber Alley. After stealthily looking both ways, he crossed Main Street and ran up the long flight of stairs next to the Railroad Hotel, hoping he could get in and find a closet to hide in. But it was too late.

The Union soldiers in Elkridge had telegraphed a warning about their escaped prisoner. By the time he got to town, they were already on the lookout for him. And they didn't have to look far, because many of the Patapsco Guard were bunking at the Railroad Hotel.

The story goes that the young Confederate made it to the third floor of the hotel, where two Union soldiers saw him. Frightened, he turned around and started running down the same steps he had just come up, hoping he could escape and run into the woods along the train tracks as he'd done in Elkridge.

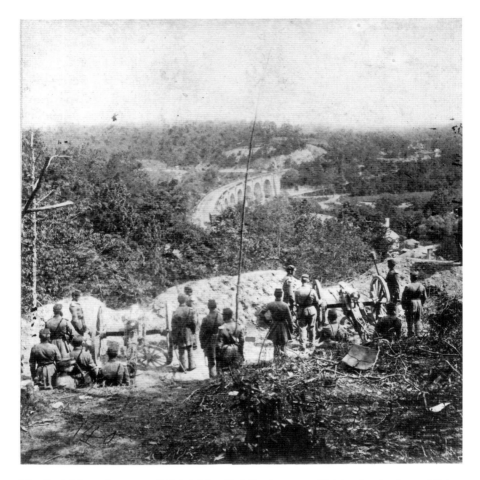

The Sixth Massachusetts and Eighth New York Regiments and Major Cook's Boston Light Artillery guarding the Thomas Viaduct, May 5, 1861. *Howard County Historical Society.*

Unfortunately, this time he was not so lucky. He had taken just a few strides down the dark steps when one of the Union soldiers took aim and shot him in the back. The impact of the bullet tumbled him head over heels down the steep steps. By the time the two soldiers got to him, he was dead. When they turned him over, they saw his lifeless eyes slowly open to stare up at the moonless sky.

The killing could be called justified, since the Civil War was raging and the man was an escaped Confederate soldier. But since he was shot in the back, murder might be a more appropriate description.

Whatever one wants to call it, the violence of this tragic event seems to be trapped in time. It's a paranormal recording that, on moonless nights, plays over and over again. Witnesses to the phenomenon say they've heard the pounding sound of running feet on the third floor of the building where the presence of the young soldier can still be sensed. Paranormal investigators have detected motion on the steps. And a few say they have seen the shadowy apparition of a Confederate soldier running for his life down the steep outdoor stairway between the Railroad Hotel and the Town Hall. Even in death, there seems to be no rest in Ellicott City for this runaway Civil War prisoner.

TOWN HALL

DEADLY DRAMAS TAKE THE STAGE AT AN EMPORIUM FILLED WITH HISTORY AND HORRORS.

EASILY THE TALLEST BUILDING ON Main Street, the Town Hall may also be among the oldest. Known variously as the Opera House, the "new Town Hall," Rodey's Amusea and, most recently, the home of the Forget-Me-Not-Factory, the structure located at 8044 Main Street is built into the steep granite slope on the north side of what was originally the Old National Road. Over the past two centuries, the Town Hall has opened its doors to a wide variety of visitors and residents. Most moved on, but, according to local lore, some spirits remain there to this day to give the living a glimpse of the lives left behind.

THE HISTORY

Rising five stories above Main Street, the towering stone and brick Town Hall building is erected on land owned by the Ellicott family. The first building on the property may have been the humble stone tavern described by Joseph Scott, author of the *Geographical Description of Ellicotts Mills*, published in 1807.

In 1830, the Ellicotts partitioned the land, and Lot 4 passed into the hands of Andrew and John Ellicott. They sold the lot that the Town Hall would be built on to Andrew McLaughlin of Baltimore, who quickly got into financial trouble. In late 1833, he persuaded the Maryland General Assembly to allow him to hold a lottery the following year to sell off his property.

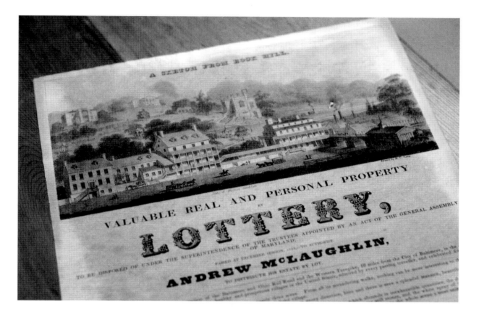

The 1834 lottery poster shows the Patapsco Hotel and other major landmarks at the time. From the Howard County Historical Society's archives. *Steve Freeman.*

Participants in the 1834 lottery paid ten dollars per ticket for the chance to win McLaughlin's lots and buildings as well as a variety of valuable personal items. The winning tickets for the lottery were drawn in September, and Joseph Barling, an accountant from Baltimore, walked away as the winner of the Patapsco Hotel and presumably the Town Hall, which may have been part of the hotel complex.

In 1846, the Town Hall building was foreclosed on. Thomas Wilson, the president of the Granite Manufacturing Company, bought the hotel properties to house workers for the new textile mill he was building on the Baltimore County side of the Patapsco. Wilson leased the building to John Schofield in 1857 for seventy-five dollars a year for a period of ten years.

The next year, Schofield borrowed $2,000 from the Independent Order of Odd Fellows, Centre Lodge No. 40, to renovate the building. He replaced the original gable roof and dormers with a tall fifth floor made of brick, replaced the old front porch with a balcony and built an addition on the east side of the building to house a staircase. After the renovations, the building became known as "the new" Town Hall.

During the Civil War, the 101-member Patapsco Guards, formed in 1861, was assigned to provost marshal duty at Ellicotts Mills. Acting as something

like today's military police, the guards had their offices on the top two floors of the Town Hall. The large meeting room on the fifth floor was used to house Confederate prisoners, as well as Union deserters and soldiers who had been drafted but failed to report on time.

Death was a frequent visitor. In 1861, twenty-year-old Nathan Bortle died of pneumonia. The Twelfth New Jersey Volunteers, who stood guard over the town after the Patapsco Guards moved on, lost six of their soldiers to diphtheria, typhoid, pneumonia or dysentery. A few of the deaths, like that of Martin Toole—run over by a train while guarding the tracks in early 1862—were accidents. At least one other was the result of horseplay gone horribly wrong.

As part of their duties, the Patapsco Guards patrolled the covered bridge over the Patapsco on the Howard County side of the river, while soldiers from Company B, the Sixtieth Regiment, New York Volunteers guarded the Baltimore County site.

During a changing of the guard on November 18, 1862, William Knight of the Patapsco Guards was horsing around with Private Simon Fishbeck of New York in a mock bayonet fight. Fishbeck's gun went off, wounding Knight in the shoulder. Dr. McGlaughlin, who had witnessed the shooting, came to his immediate aid. Despite the doctor's swift action, Knight died of his wounds minutes later. The incident was made even more tragic by the fact that New York troops weren't allowed to carry loaded guns in the daytime. Unfortunately, according to Fishbeck, he had picked up a loaded gun that had been left over from night sentry.

In 1867, Michael Bannon bought the building and turned it and Schofield's presses over to Isaiah Wolfersberger, the publisher of the *American Progress* newspaper, which he began putting out in 1871. Business didn't boom as much as Bannon hoped, so in 1885, John G. Rogers purchased the Town Hall in a foreclosure auction. Wolfersberger continued to publish his newspaper at the building between 1890 and 1896.

Nine years later, the shop at street level was a hardware store. The first floor continued to be home to a printing company. The second and third floors were rented out to Oppenheim, Oberndorf & Co., a shirt manufacturer, while the top floor remained a lodge room. Shortly after 1894, the shirt company moved away to a factory on Fels Lane and the upper floors were converted into tenements; the first floor became a billiard hall.

In 1906, Rogers sold the building to Edward A. Rodey, who added the storefront windows to the street-level shop. Renamed Rodey's Amusea in 1912, the building became home to a silent-movie theater. The theater's

Military Troop A (minus Ellicott City unit) readying for 165-mile Gettysburg march, 1904. Town Hall and the Railroad Hotel are in the background. *Howard County Historical Society.*

stage was also used by local theatrical companies to put on plays and musical productions, which may be why the building is also known as the Opera House.

Rodey sold the building in 1923 to Nannie and Charles Yates, who opened a grocery store there. It changed hands many times in the following years, housing tenants that included Bill Hood's Grocery and Ecklof's Furniture Store.

In 1985, Barry and Nancy Gibson bought the property and gradually, floor by floor, renovated the building. During their years of restoration, they discovered a variety of fascinating objects, including Victorian shoes, plates, bottles and marbles. Perhaps the most valuable treasure the Gibsons uncovered is a 1789 gold coin found in one of the fireplaces. By the mid-1990s, Gibson's iconic Forget-Me-Not Factory store occupied all five floors.

In the more than two hundred years that the building has existed on the site, the interior floor plan has been reconfigured many times. But that's part

of its charm. Today, visitors make their way through a maze of goody-filled rooms and stairways that wind up to the large and open "meeting room" on the top floor, where they can catch their breath and make their way back down again.

THE HAUNTING

It goes without saying that a building as old as the Town Hall has seen a lot of history—some pleasant, others tragic. Local legend has it that John Wilkes Booth had his theatrical debut here in the late 1850s. He would have been much too young at the time, so that story is generally dismissed as being untrue.

Other accounts of troubled souls wandering through the Town Hall's tortured maze of rooms can't be tossed aside so easily. In addition to employees frequently hearing ghostly footsteps on the second floor above them and the distant tinkling of piano keys, there have also been sightings of the ghost of a little girl in a light blue dress.

Predictably, the building has drawn intense interest from psychics and paranormal investigators alike. One felt a blast of cold air as she saw a vision of a stagecoach come hurtling out of an interior wall, supposedly in an area where the original tavern may have stabled horses.

In the 1980s, a team of paranormal investigators prowled the building. When they got to the fifth floor, the indicators on their ghost-detecting gear went crazy. Despite the fact that the room was not air conditioned, the team felt pockets of icy air envelop them as they explored the space. At one point, one of the investigators who was wearing a cross on a necklace felt it fall to the floor. When she checked the loop, it was perfectly intact. Film developed after the investigation revealed a room filled with luminous floating "orbs," balls of light that are believed to be manifestations of people who have passed on or simply residual psychic energy of traumatic events.

Sometime after the investigation, a friend of the owner who claimed to be sensitive to the supernatural visited the store. When they reached the top floor, he stepped back in horror as he began to have a vision of a woman in a Victorian dress being attacked by a man. He felt the man was attacking her because she had something very valuable in her possession. He also felt that she was about to be killed for it.

Looming over lower Main Street, nearly every floor of the Town Hall has a story and a spirit. *Shelley Davies Wygant.*

After recovering from the initial shock of his disturbing vision, he pointed to a spot on the wall where a fireplace used to be. He said that that is where her body was hidden after she was murdered—the same spot where the cross had mysteriously fallen off the paranormal investigator's necklace. No physical remains were ever found in the closed-up fireplace, but, apparently, something stayed behind to alert the living to the lingering presence of the dead.

Daniel Shea's Tobacco Shop

DID THE ACRIMONY OF A MURDER AND LYNCHING GO UP IN SMOKE IN THE AFTERLIFE?

ALTHOUGH IT IS THE COUNTY seat, at just thirty square miles, Ellicott City qualifies as among the smallest of small towns in Maryland. Ties and tensions between white and black residents run deep, with many unwillingly sharing common ancestors. After the Civil War, many former slaves stayed on to serve as paid laborers on the family farms where they were born. Others, like Jacob Henson, who was born at MacAlpine, the home of wealthy lawyer and landowner James McKubin, went on to get jobs in town.

According to historical records, shortly before the turn of the twentieth century, Henson worked at one of "Carter's 5 Shops" located between 8048 and 8056 Main Street, where his spirt and that of his doomed employer may still remain.

The History

Embedded into the north side of the lower end of Main Street, the row of three-and-a-half-story brick buildings known as Hill, Robbins and Carter's 5 Shops stands on the fourth section of Lot 1 in McLaughlin lottery of 1834. In 1865, Thomas Wilson sold this part of Lot 1 to the Granite Manufacturing Company for $3,500. Seven years later, in 1872, George Feelemyer probably bought what was still vacant land for the same price and constructed the buildings sometime before 1887.

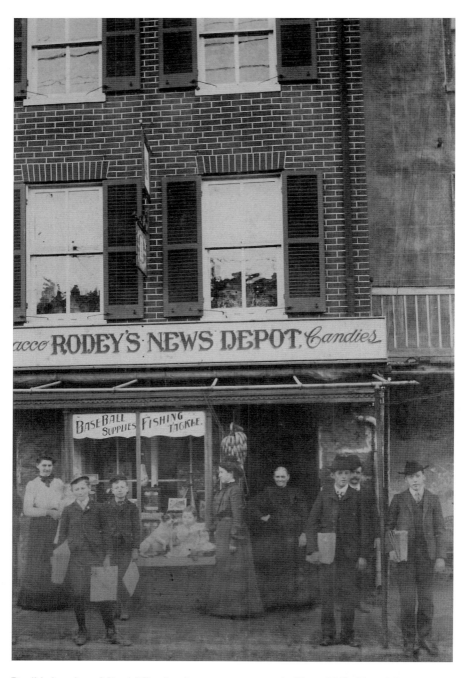

Possible location of Daniel Shea's tobacco store next to the Town Hall. *Howard County Historical Society*.

Tiny by modern standards, with just 1,632 square feet of living space, each of these buildings has just a window and a door at street level. The second, third and fourth floors of the buildings are home to equally small apartments whose windows look out over the lower part of Main Street.

Over the years, a wide variety of businesses have operated out of the storefronts, including tobacco and barbershops, psychics, jewelry stores and a hot dog shop. Few people know that this quirky and quaint set of structures holds a very dark secret and perhaps at least one otherworldly inhabitant.

The Haunting

Typically, the first requirement of any ghost story is a death. Natural ones are common. Murders are not. The ghosts that may roam these buildings arise from the latter—a violent murder at the site, and an even more terrible one that was carried out not far away.

The year was 1895. The location of the crime was Daniel F. Shea's tobacco shop. While the 1887 Sanborn map shows a tobacconist at 8054 Main Street, other accounts say the shop was in a room in the building immediately adjacent to the Patapsco Hotel/Town Hall. Although the exact place of the shop is unclear, what happened the night of February 19 was well documented by the *Baltimore Sun*. Here is a compilation of the 1895 newspaper accounts that detail what happened from gruesome start to horrific finish.

Jacob Henson, a young African American store clerk, walked over to his employer's country store during the closing hours of February 19, 1895 to enjoy a few beers. Henson and his employer, Daniel F. Shea, enjoyed the beverages as they were locking up the store for the evening, when all of a sudden a fight broke out between the two men. Mr. Shea reportedly struck Jacob Henson in the chest with his fists three times. Enraged, Henson picked up the first thing he saw on the ground, a hatchet, and proceeded to hit Daniel Shea in the head a number of times, causing Shea to collapse in the corner of the room. Frightened, Henson ran away from the store, but not before neighbor John Dorsey caught sight of him fleeing the scene. Mr. Dorsey then entered into Daniel Shea's store and found him dead. When Shea's body was examined, doctors found over 20 distinct gashes in the skull of the store keeper.

Probable location of Daniel Shea's tobacco store identified as a "tobacconist" shop on the 1887 Sanborn Fire Insurance Map. 2018 photo. *Shelley Davies Wygant.*

Authorities found Jacob Henson at his home in Ellicott City, Howard County, and arrested him for the murder of Daniel Shea. Henson explained that his actions were in self-defense, explaining that Mr. Shea struck him in the chest first. Detectives found blood on both Henson's clothes and the hatchet used to kill Shea. While in custody, Henson confessed these events to Deputy Warden Robert H. Hollman, emphasizing that it was an act of self-defense. Henson was held in the county jail on Ellicott City's Main Street until a trial date was set.

On March 28, Jacob Henson was in court for the murder of Daniel Shea the previous month. Henson's representation, an experienced African American lawyer named W. Ashby Hawkins, argued that Henson was of unsound mind, and he pled to the jury not to sentence his client to death by reason of insanity. Detective Herman Pohler of Baltimore also heard the confessions given by Henson while he was in custody in Ellicott City, and although he agreed that Henson was slow and "stupid" at times, he was still competent enough to realize his actions. This conclusion was confirmed by a number of doctors who interviewed Jacob Henson while he was in jail. Chief Judge Roberts heard the case, and the jury only needed 25 minutes to deliberate and returned a verdict of guilty to the first-degree murder charge. The jury claimed that the attack was premeditated and organized by Jacob Henson the night before.

First-degree murder was a capital offense and Henson was sentenced to death by hanging, which was scheduled to take place on June 7. Henson's attorney immediately asked for a suspended sentence because he was going to file for appeal based on the grounds that Jacob Henson was of questionable mind and did not know the difference between right and wrong. The next day, Mr. Hawkins argued his case, and although praised by State's Attorney McGuire for his articulate appeal, the amount of submitted evidence stacked up against Henson was too much to overturn the verdict. On April 2, Judge Jones found that Jacob Henson was guilty of the murder of Daniel F. Shea. This was the first time that Justice Jones handed down a death sentence in any case he had heard in his career.

There were a number of doctors from the Maryland Lunacy Committee that interviewed Henson while he was in custody, and found that he knew what he was doing, and therefore should be held accountable for his actions. Mr. Hawkins stated that council would appeal to Governor Brown for at least an executive clemency decision because of Henson's lowered mental capacity. This is the point when tensions began to rise among the community.

Jacob Henson could do nothing but wait for June 7 to arrive and accept his sentence. On the night of May 27, citizens of Howard County were afraid that the governor would be lenient on Henson and grant his lawyer's wish of clemency and reduce the sentence, most probable to life in prison.

Just after midnight on May 28, 1895, 15 or 20 armed and masked men approached the Ellicott City jail where Henson was held. Warden Lilly's son-in-law, Robert Hollman, and an African American worker named Joe Geurus were on watch that night, and at gun point, the two men could do nothing more to protect their inmate from the angry mob. It took the men a short while to enter the jail using an iron bar to break through the wooden door. Jacob Henson heard nothing until the men used a sledgehammer to break the iron lock of his cell door.

Ordered to get dressed, Henson screamed for the men to take mercy on him. The masked men then tied a rope around his neck, bound his hands, and gagged him as they dragged Henson out of the jail. The mob then led Jacob Henson to Merrick's Lane beyond the Patapsco Heights area, a short walk up the hill from the jail. Afraid of what awaited him, Jacob Henson fainted, and was dragged the rest of the way to a dogwood tree on the property of A.B. Johnson, where Jacob Henson was hanged. A placard was left under the body with the statement "Governor Brown forced the law-abiding citizens to carry out the verdict of the jury."

In May 1895, an angry mob dragged convicted murderer Jacob Henson out of the Ellicott City Jail (Willow Grove/Emory Jail) to be lynched. *Howard County Historical Society.*

By daybreak, the body of Jacob Henson was still in the tree, and Undertaker Hillsinger was ordered to place the body in a coffin, bring it to the jail, and get an interment for the body somewhere in Ellicott City. Unable to find a plot, the undertaker then looked into some of the African American cemeteries in the vicinity, but with no luck. When the relatives of Jacob Henson were contacted, they originally planned to give their son a proper burial, but since he was lynched, they wanted nothing to do with the body. As a last resort, Sheriff Flower agreed to take the victim's body to his farm, and buried Henson in a cemetery located there. During this time, the dogwood tree that Henson was lynched on had been cut down and relic-hunters took pieces of it as souvenirs to commemorate the spectical [sic].

What was the cause of the argument between Shea and Henson that turned so violent? The men seemed to be friends or at least friendly. Yet one hacked the other to death and paid the ultimate, if unjust, price for killing him.

Despite the horrible nature of the crimes, the ghost or ghosts at the row of brick buildings seem benign. Over the years, tenants of the apartments above the shops have reported the typical odd sounds and objects moved by

unseen hands that are associated with haunting. They have also noticed one other telltale sign that spirits are present.

Sometimes, late at night, when the ground-floor shops have closed, the faint sweet fragrance of tobacco smoke can be detected wafting around the upstairs fireplace. Perhaps Daniel Shea and Jacob Henson, his employee turned murderer, have finally found peace together sitting in front of a phantom fire at the old tobacco shop on Main Street.

CACAO LANE RESTAURANT

HAUNTED MIRROR TERRORIZES STAFF IN A RESTAURANT PLAGUED BY CATASTROPHIC FLOODS.

ORIGINALLY KNOWN AS THE ALEXANDER House, then later as the home of Hunt's Dry Goods Store and Elizabeth Hunt's Ladies Millinery Shop, the three interconnected stone structures at 8066–8077 Main Street were most recently the site of Cacao Lane Restaurant, which served Ellicott City diners for more than forty years. The group of structures that started as a home and went on to house businesses that sold everything from housewares and hats to fine dining and highballs is also the dwelling place of spirits who feel compelled to make their presence known.

THE HISTORY

Like most of the property in downtown Ellicott City, the side-by-side granite stone buildings that housed Cacao Lane stand on land that was originally owned by the Ellicott family. Lots 3, 4 and 5 where the buildings now stand were auctioned off in the lottery of 1834.

Just a few years later, on May 4, 1837, Edward Clarendon Alexander bought the western part of the property, Lot 3, from Hiram and Elizabeth Meyers. On November 20, 1840, he purchased the east section from Llewelyn and Catherine Jones for the sum of $200. Alexander, who was a physician, may have been renting the property, as the deed noted that he was in the "quiet and peaceable possession" of the premises at the time of the sale.

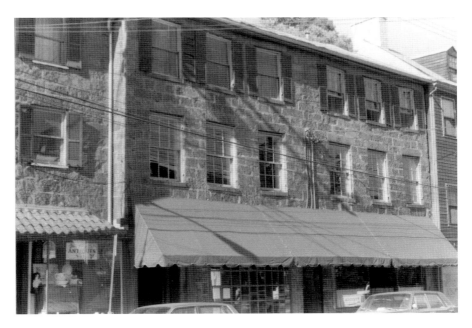

Site of Cacao Lane Restaurant, formerly the Alexander House, Hunt's General Store and Hunt's Ladies Millinery Shop. *Howard County Historical Society.*

Over the next decade, records show Alexander passing portions of the property into various hands. Despite selling off pieces and parts of the property, the U.S. Census shows that Dr. Alexander was still living in Ellicotts Mills in 1850. The record shows him residing there with John Chase, a nine-year-old African American boy who was probably his slave.

By the 1870s, members of the Hunt family owned the entire building. Between 1873 and 1912, Ann Hunt's son Thomas H. Hunt operated a general store in the eastern half of the building. His sister Elizabeth Hunt ran her Ladies Millinery Shop out of the western half. It's said that she lived to be nearly one hundred years old and never married.

After Thomas Hunt's death in 1911, a court action appointed Robert Biggs and Garnett Clark as trustees for the property in preparation for its sale. On November 16, 1920, local businessman Benjamin Mellor bought it at auction for $2,200 and a year later sold it to Russian-born merchant Hymen Rosenstock.

The 1930 U.S. Census shows Rosenstock, along with his wife, Pauline, their son Lee, daughter Florence and her husband, Nathan Levin, living in a home they owned on Main Street in Ellicott City. After Hymen's death, the

property was passed on to his son. During the time Lee Rosenstock owned it, the lower floor was leased out to a bar, a pool hall and a taxi stand; the upper floors were used as apartments.

Everything changed for the building and the town of Ellicott City on June 21, 1972. On that day, the massive remnants of Hurricane Agnes slowly lumbered up the east coast from Florida and into Maryland. Heavy rains began to fall, and by 11:00 p.m. the Patapsco River had jumped its banks at Ellicott City. After midnight, witnesses describe the flood coming "like a wall of water." Within an hour, the river had risen ten feet, cresting at forty feet higher than normal. The floodwaters, along with whole trees and tons of debris, raged down the valley, flooding Main Street and lower Ellicott City up to Caplan's Department store under ten or more feet of water.

When Rosenstock got to the property, he found the first floor of the building filled with mud, tree branches and the remnants of destruction that had flowed down from the mill town at Daniels. It was too much to bear. So, just three months later, on September 12, 1972, he sold the building and Campbell House next door to Dennis L. Brown.

After the flood, the very existence of Ellicott City was in question. Many thought the town should be abandoned. But visionary entrepreneurs like Brown saw a way to the light, where others saw the open pit of the town's grave. After spending tens of thousands of dollars for cleanup and renovation, Brown opened a restaurant he called Cacao Lane. Brown ran the restaurant until 1983, when he sold the property to Herbert Koerber. Three years later, in 1986, Koerber sold it to Allen L. Parsons, who ran the restaurant and lived above it with his family.

Occupying the entire first floor of the two-part building as well as the Campbell House next door, the restaurant was a maze of stone- and brick-walled rooms linked by short flights of steps and a dim passageway that connects the east side to the west side. The bar was set up in the old millinery shop, while the main dining room was located in the former dry goods store—guests could sit at tables in what had been the shop's display windows. Diners could access the second dining area located in the Campbell House up another short flight of stairs. When Parsons opened the second floor for live entertainment and built outdoor decks high up on the steep hillside behind the building, the restaurant's floor plan challenged guests with even more twists and turns.

Cacao Lane remained a popular dining destination until July 30, 2016, when more than six inches of rain fell on the town in just two hours. The

storm sent a fast-moving, ten-foot-plus flash flood down Main Street, destroying businesses and leaving at least two people dead. Forty-four years after Agnes, floodwaters once again reached the ceiling of the first floor of the Cacao Lane building. This time, it was no slow inching up of water, but rather a fire hose of destruction that scoured out the restaurant's interior. The flood wiped Cacao Lane out of existence. The building was in the process of being renovated when disaster struck again in the flood of 2018. As of this writing, the building is empty, at least of living souls. Its future is unkown.

THE HAUNTING

With its beginnings in the early 1800s, the three-part building complex that became Cacao Lane has had plenty of time to accumulate the psychic energy of past residents, shoppers and pool hall hustlers as well as restaurant guests and waitstaff.

Tales told by employees of the restaurant over the years bear that out. Whether it's hearing footsteps or feeling uneasy in the empty upstairs, sighting a phantom figure in a white shirt roaming the mezzanine or being startled by bar stools that mysteriously turn around, everyone from bartenders to busboys seems to have experienced something spooky.

The most infamous tale of a supernatural happening at Cacao Lane happened not all that long ago, so eyewitnesses to the event might still be around to confirm what everyone saw that night.

It seems that, a short while after the last guest left, the staff were taking a break before closing the restaurant. A group of them, including a few waiters, a cook, a dishwasher and the bartender were hanging out in the first-floor bar area. Some were chatting. Others were silent, simply relaxing after an exhausting day.

It's said that at some point, the bartender who had been looking out the large bay window at the now empty Main Street turned back to the group. As he did, something on the wall behind the bar caught his eye.

He uttered a soft, "Hey, look" to the group as he pointed to one of the mirrors hanging on the brick wall and then froze. The rest of the group looked up to see the mirror slowly rise straight up in the air by itself, leaving its hook on the wall. As strange as that was, it was just the beginning of the manifestation.

Instead of immediately falling to the floor with a huge crash, the looking glass seemed to hover above the shelves loaded with bottles of liquid spirits as if it was being held by some unseen presence. As the group stood stunned by the sight of the slowly descending mirror, the wire on the back of the frame caught the necks of a few bottles on the bottom row. The sound of the bottles crashing down broke the trance, and everyone ran out the front door.

It wasn't until the next morning that they found the mirror on the floor behind the bar. The only broken glass they found was from the broken liquor bottles. The mirror itself was unharmed.

Despite its part in what everyone agreed was a chilling display of paranormal activity, the manager rehung the mirror in its place on the wall behind the bar. Patrons continued to glance at their reflection for many years. It remained in place until the flood of 2016. That night, the raging waters of a catastrophic flash flood broke through the front windows of Cacao Lane and swept the haunted mirror into the swirling depths of the Patapsco River, never to be seen again.

Centre Lodge No. 40

LOVE, FRIENDSHIP AND TRUTH ENDURE BEYOND THE GRAVE AT THIS HALLOWED HALL.

IN TIMES OF SORROW, COMMUNITY spirit sometimes takes on a whole new meaning. That certainly may be the case at the Independent Order of Odd Fellows Centre Lodge No. 40. Located at 8134 Main Street, the handsome stone building is home to one of Ellicott City's oldest charitable social organizations—and perhaps the ghost of a young man who embodied the order's highest ideals.

THE HISTORY

Likely built by Robert Mickle before August 14, 1848, when it was purchased by Isaiah Mercer for $625, the lodge is one of the few completely detached and among the oldest buildings on the north side of Main Street. In 1859, the handsome three-and-a-half-story granite building passed into the hands of Isaiah's son William. Records show that G.F. Hess had a harness shop there until 1860.

In 1863, the Mercer family sold the building to the Centre Lodge No. 40 of the Independent Order of Odd Fellows for $2,000. Instituted in Ellicott City in 1843, the organization was founded in eighteenth-century England by community-minded men, women and young people who shared a belief in a supreme being and that friendship, love and truth are the basic guidelines that should be followed in daily life. The name comes from the

Milton Easton, International Order of Odd Fellows Centre Lodge member and owner of Easton Sons Funeral Parlor. *Howard County Historical Society*.

fact that at the time the order was founded, it was "deemed odd" to find people organized to unselfishly care for those in need and work to benefit all of mankind.

Until at least the late 1970s, a plaque in the form of three links of chain, symbolizing the order's ideals, was affixed to the front of the building between the second and third floors. Although the lodge's third-floor hall has remained an Odd Fellows meeting place since 1863, the second floor houses apartments, and the first floor has been home to a wide variety of shops over the years.

The Haunting

Although the Centre Lodge has been part of the Ellicott City community for well over 150 years, its ghost is of fairly recent vintage. It seems that early in the 1970s, the lodge inducted the son of one of its members. The young man, whose name was Tom, was very excited about becoming a member. To express his appreciation and dedication, he cheerfully took on the task of setting up the hall for the order's Thursday night meetings. He'd get there early, set up the tables and chairs and stand at the top of the steep stairs to welcome each member as they came through the door. He did it every week, like clockwork, until one fateful day.

While driving back to Ellicott City from western Howard County, Tom got into a horrible car accident. A car came barreling around a bend in the road and into Tom's lane. The head-on collision killed him instantly.

When the lodge members heard about the crash, they immediately cancelled their next weekly meeting out of respect for the young man. However, the more they thought about it, they decided that Tom wouldn't have wanted them to cancel their meeting because of him. They called around to all the members and made sure a few got there early, because they knew Tom wouldn't be there to set things up.

But when they climbed the stairs and opened the door to the meeting room, they stood stunned. Everything, the tables and the chairs, as well as the meeting materials, had been set up. Who did it? Did one of the members slip in to perform a silent service for the order? Or was it Tom's final good deed and goodbye to the people and the organization that meant so much to him?

Today, the Odd Fellows still meet in the hall on the top floor of the building, and strange things continue to happen. Tenants living in the apartment below the hall decades after Tom's tragic

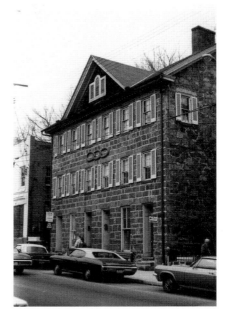

International Order of Odd Fellows Centre Lodge. The exterior stairway is on the left side of the building. *Howard County Historical Society.*

death say that exactly half an hour before the members arrive, they hear footsteps above and sounds of chairs moving across the old wooden floor above them. The first couple of times it happened, the couple ran upstairs to check it out. No living soul was ever there. So, every Thursday, they just exchange knowing glances whenever they hear the sound of chairs being pushed into their proper places in the empty hall above them.

HOWARD HOUSE HOTEL

A PLACE WHERE PEOPLE FEEL COMFORTABLE STAYING. SOMETIMES FOREVER.

TOWERING FIVE STORIES ABOVE ITS rock-solid granite foundation, the Howard House Hotel has a storied past that includes fatal workplace accidents, restless former residents and what may have been a sweet final stop on the way to the afterlife by one of the town's most respected residents.

THE HISTORY

Constructed by James Shipley around 1840, the Howard House Hotel at 8202 Main Street towers over the corner of Main Street and Old Columbia Pike. It's sited on of a tract of land originally called West Ilchester on Lot 149 on the sale plat of the property of Jonathan Ellicott and sons.

Like most buildings on the north side of Main Street, the Howard House is set into a steep slope of living granite so that the third floor of the front elevation is the ground floor for the back of the building. The back of the building faces what is now Church Road, originally called Ellicott Street.

In 1842, the property was sold "for the use of" James's wife, Harriet, for $1,000. Later that year, it was auctioned for $1,800 to William Worthington. Bad luck seemed to haunt the property, because William couldn't make the payments and had to put the property up for auction in 1843. Thomas Anderson bought it at the bargain price of $1,545 and leased it to George Bond, who was the town postmaster from 1855 to 1858. In 1865, Josiah

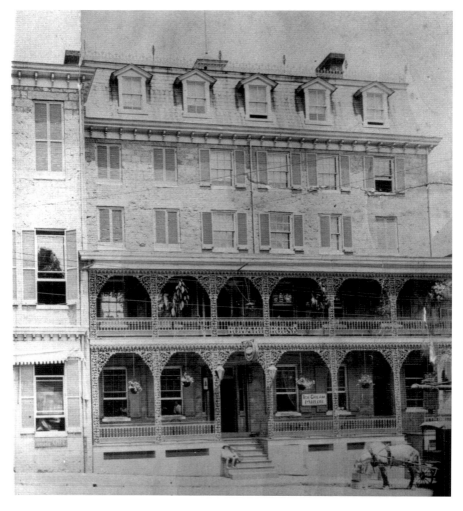

Howard House Hotel, circa 1890s, featuring a shop that served homemade ice cream, ginger ale and sarsaparilla. *Howard County Historical Society*.

Groves, who arrived in town in 1850 and ran the hotel, bought it for $2,500. Fourteen years later, the hotel was sold to Christian Eckert for the sum of $5,680.

After a somewhat rocky start, the enterprise took off. The Howard House became a favorite place for visitors to Ellicott's Mills to dine and lodge. The hotel's bar was located on the first floor; the dining room was on the second floor.

Hotel stationery from the Howard County Historical Society archives advertises a variety of appealing Howard House amenities. *Steve Freeman.*

In 1882, the town enacted a law forbidding the sale of "spiritous, fermented or intoxicating liquors," forcing Eckert to close the hotel bar. So, to make up for lost revenue, he started producing homemade ice cream, ginger ale and sarsaparilla. According to local lore, townspeople used Howard House as a shortcut to get up the hill from Main Street to the courthouse. Eckert was glad to make the shortcut available, since many people stopped to enjoy his fine German food.

The Howard House Hotel became so successful that, sometime in the 1890s, Eckert built the adjacent Greek Revival granite building at 8210 Main Street. Known as the "New Building," it featured a lunch room and a large banquet hall on the second floor that could serve as many as 150 diners at a time. Later, the banquet hall hosted silent movies accompanied by a player piano as well as occasional wrestling matches.

When Mrs. Eckert died, Christian sold the Howard House to his sister-in-law and her husband, Mr. and Mrs. John Reichenbecker, for $25,000. They managed the hotel for three years and then sold the property back to him. On December 2, 1910, Christian Eckert sold the property for $18,000 to William F. Kerger. During the rest of the twentieth century, the building changed hands many times and had many uses, including as apartments and retail space. In 2011, the ten-thousand-square-foot Howard House Hotel property, which has eight residential units as well as two businesses, was sold for $1.2 million.

THE HAUNTING

Over the years, hundreds, perhaps thousands of hotel guests, apartment dwellers, maids, waiters, cooks and workmen have walked the worn floorboard of the Howard House Hotel. Most checked out, but undoubtedly many seem to have remained.

Among them is a spirit that a tenant who lived in an apartment on the top floor of the Howard House named "Dennis." The ghostly phenomena began as soon as she moved in. She heard odd, unexplainable sounds. Pans clanged in the middle of the night. A male voice murmured words she couldn't quite make out. Cold spots came and went in her living room and kitchen, causing her cat to flee with his fur standing up and then refuse to go into that part of the apartment.

The unexplained happenings continued until she had to go out of town and asked a friend to stay in the apartment and watch her cat. This friend supposedly could communicate with spirits, so the tenant asked her if she could try to find out who "Dennis" was and why he was in the apartment.

When the tenant came home, her friend told her she had "talked" to the ghost. She believed he was a young man who had died while construction was being completed on the building in 1850. It seems he had fallen through the unfinished roof on the Church Road side of the building and died in the space between her kitchen and living room, where she had felt the cold spots. The friend said that the spirit of the young man had wanted to leave but didn't know how.

Two weeks later, an employee at the Howard County Welcome Center who had done some historical research confirmed the story of the accident. After that, the unexplained ghostly phenomena ended. The cat calmed down. Apparently, the tenant's friend had been able to help "Dennis" finally check out of the Howard House Hotel.

ANOTHER TALE CONNECTS THE HOTEL with the resident of Mount Ida, the haunted Ellicott family mansion that was home to prominent businessman Louis Thomas Clark and his family.

Born in 1871, Clark was in his late fifties when he purchased Radcliffe's Emporium, the stone building on the north side of Main Street next to the Patapsco River, and began running it as a grocery. For almost thirty years, Clark walked down that road to Main Street and down to his store in the morning and walked back home at the end of the day.

According to local legend, he occasionally made a stop to visit with neighborhood children on the back porch of the Howard House Hotel to regale them with stories of times gone by. The story goes that, one afternoon, Clark told stories later in the day than usual. Most of the large group of children had drifted off, leaving only two young boys. They loved the elderly man and his tales of the past and didn't want the afternoon to end.

Finally, Clark got up to leave his comfortable seat on the Howard House Hotel back porch and said to the boys, "Well, young gentlemen, it's time for me to go."

When the children asked when he'd be coming back to tell more stories, he said in his quiet southern drawl, "Oh, I don't think I'll be back for quite a while." Then he turned and started walking up Church Road.

Just as he disappeared around the bend at the top of the hill, the boys heard the screams of an ambulance siren and watched it race up Church Road followed by police cars. A little while later, one of the police cars drove back slowly down the hill. The boys flagged them down to ask what had happened.

"We were just up at Clark's," the police officer explained.

"What happened?" asked the boys. "Mr. Clark just left here a little bit ago. He'd been telling us stories for hours."

"No, that can't be, boys," said the police officer. "Mr. Clark has been dead for over four hours."

Louis Thomas Clark died in Ellicott City on December 3, 1957, and is buried with family members in St. John's Cemetery—perhaps after one last visit to the town he loved.

8

DISNEY'S TAVERN

OLD WATERING HOLE IS HOME TO WINE, WOMEN AND THE SWEET SCENT OF A FRIENDLY GHOST.

EVEN THOUGH IT'S ONE OF Ellicott City's oldest buildings, tourists strolling along the sidewalks toward the west end of town typically don't notice the handsome stone duplex at 8304–8298 Main Street. That is, unless the friendly owner of the bookstore at that location looks up from whatever he's reading and nods to them from the front porch. However, they should give the building known as Deborah Disney's Tavern and the Sprecher House more than a second look. The building where countless glasses of wine, beer and stronger spirits have been raised over the past two hundred years may also be home to the ghost of Main Street "royalty."

THE HISTORY

It's said that this two-and-a-half-story stone building, which is now covered with blocked-out cement veneer, may date to as early as 1790. Although it's currently divided into two halves, it may have started as a single-family home.

In 1819, the property was put up for sale. Records show that Irvin McLaughlin bought ten acres of the land grant known as Mount Misery from Elias, Thomas and William Brown. The price for the property was a princely $500 an acre. The terms were that McLaughlin would put $100 down and pay $400 within four months. He then agreed to pay the rest in three equal payments.

Few people at that time had that much cash on hand, so McLaughlin borrowed money from the Ellicotts in 1824 to pay for it. He must have had a hotel or tavern on the site, because the loan was based on personal property that included eight mahogany tables, fifteen beds (with bedding, sheets and blankets), five chamber looking glasses, carpets, china, curtains, silver, eight dozen wine glasses, four horses and a cow. The value of the collateral came to a total of $1,419. That wasn't nearly enough to pay what he owed the Browns. He failed to make the agreed-upon payments and died a penniless debtor.

The foreclosed property was auctioned off in 1826. The Browns repurchased it for just $6,250. They kept it until 1829, when they sold the ten acres that at that time included the tavern house, storehouse, stables, outhouses, all the stock, furniture, animals and Negroes to William Lorman.

This is where the history gets interesting. On July 21, 1835, Deborah McLaughlin, the widow of Irvin McLaughlin, who originally bought the property, married Edward Disney in Baltimore City. Five years later, on June 17, 1840, Deborah bought the tavern and the same ten acres her first husband had purchased in 1819 for $6,000.

Identified on an 1860s Martenet map as "Mrs. Disney's Union Hotel," the business boomed. The welcoming tavern on Main Street was a popular place to gather for those serving on juries at the courthouse as well as travelers and residents of the town.

A little more than twenty years later, Mrs. Disney sold the property to John R. Clark for just $5,800 in 1862. Over the next thirty years, the property was bought and sold by David Sprecker, Edward A. Talbott and his son, who continued to operate it as a tavern in 1894.

Later owners of the building include William F. Lilly, his daughter Mary J. Lilly, and Norman and Mary S. Betts, who bought the left side of the building on December 1, 1947. They lived there beside their neighbors Mr. and Mrs. Harvey Wine for many years. Mr. Betts, who was a local banker, died at the home on January 16, 1967.

Shortly after Betts's death, Harry and Janet Tamburo bought the 8298 Main Street address and opened the Fabric House shop. In 1990, they sold it to George Chambers for $150,000. Today, that part of the building is home to Gramp's Attic Books. Dennis A. Hodge purchased the eastern half from Rose Marie Carter in 1994 for $145,000 and currently has his law office at the 8304 Main Street address. There is a tiny apartment off the back of the bookstore, as well as other apartments on the second and third floors.

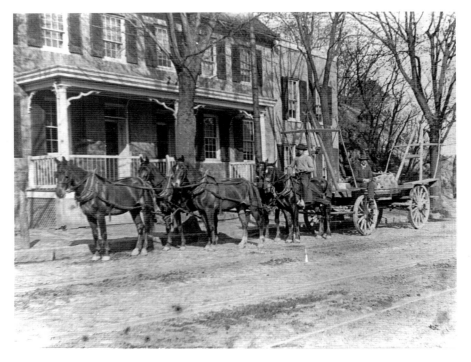

Late 1890s or early twentieth-century photo of Deborah Disney's Tavern. *Howard County Historical Society.*

THE HAUNTING

Although the building is said to be more than two hundred years old, the haunting is of a much more recent vintage. As is the case with every ghost story, this one begins in life, with the owners of the bookstore, Walter and Bernice Jackson.

Avid book lovers and collectors, the couple filled their small store with hundreds of old, used and rare volumes. Bernice, who was known as the "Duchess of Main Street," was a frequent visitor at many of the shops up and down Main Street while Walter watched over the business, often from the front porch of the store.

Wherever she went, she trailed her signature scent, a secret combination of two perfumes that only she wore. Mr. Hodges, the attorney next door, knew it well, since Bernice would often pop in for a chat. Sadly, those friendly visits ended when she suddenly passed away on March 4, 2002, in the small apartment behind the shop. Or did they?

This is a 1970s photo of Disney's Tavern. *Howard County Historical Society.*

After her death, the lawyer was frequently distracted by what appeared to be the shadow of someone approaching his front door. He would have otherwise chalked it up to tourists who often walked up the steps of his porch to get a better look at the historic building—except for one thing.

The shadow's visits were accompanied by the familiar sense of the presence of an old friend, and something else. Shortly after the figure darkened his door, the lawyer would catch the unmistakable scent of the duchess's unique perfume.

9

TALBOTT LUMBER COMPANY

RESTLESS SOULS ARE ALWAYS ON TAP AT A HARDWARE STORE TURNED BREWPUB.

LOCATED AT THE FOOT OF Capitoline Hill, the imposing stone and brick structure at 8308 Main Street is a relative newcomer to the Ellicott City streetscape. Best known as one of the town's most iconic businesses, the Talbott Lumber Company building and its tortured ghosts continue to attract visitors seeking the company of both liquid and invisible spirits.

THE HISTORY

The land that the old Talbott Lumber Company building stands on was part of a tract of land that was conveyed by Charles W. Dorsey to William Lorman of Baltimore on July 13, 1829. At the time, there was a tavern dating to 1790 located there that was frequented by both locals and travelers on their way in and out of town.

By the time Deborah Disney purchased the property in 1840, the land record book shows the addition of a store west of the old public house that would become known as Mrs. Disney's Tavern. Disney sold the property to John R. Clark in 1862. Seven years later, Clark sold the property to David Sprecker. In 1885, Sprecker sold the property along with the tavern and a store that had been built on the site to local businessman and lumberyard owner Edward Alexander Talbott for $2,000 plus the payment of a $3,000 mortgage to John G. Rogers. On December 27, 1894, Edward Alexander

Talbott Jr. and John Clark, executors of the will of Edward Alexander Talbott Sr., conveyed the deed to the property to Edward A. Talbott Jr. for $3,000.

When Edward Jr. took possession of the property, there was a brick house in addition to the store that adjoined Disney's Tavern. He decided he wanted to expand the family's lumberyard, which at that time stood across Main Street from Disney's Tavern. So, in 1905, he tore down the house and the shop and replaced them with the current structure built of brick and granite. Talbott kept the lumberyard across the street opposite the store.

Edward ran the store and lumberyard for many years, eventually passing on the business to his sons Richard and Thomas. In 1945, the two brothers sold the building and the business to Nathan Holzweig of Ellicott City and Nathan Caplan of Baltimore.

Holzweig and his wife, Ida, had two daughters, Toby and Frieda. Toby married Ben Rosen, and Frieda married Milton "Moot" Mazer. The two brothers-in-law took over the Talbott Lumber Company in the early 1970s and ran the business until 1991, when it closed.

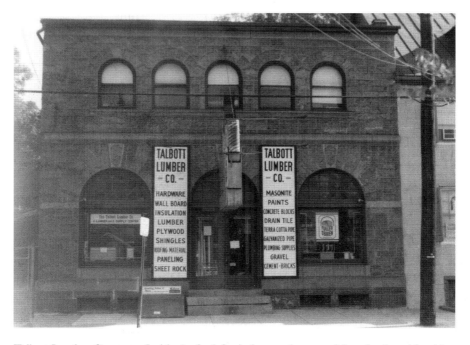

Talbott Lumber Company. Inside the far-left window on the second floor is where it's said the hanged accountant was found. *Howard County Historical Society.*

Heirs of the Talbott Lumber Company sold the building in 1995 for $396,000 to Historic Ellicott Mills LLC, which then passed it on to Talbott House LLC in 1997.

That year, the new owners, Richard Winter and Timothy Kendzirski, transformed the old lumber company into a brewpub called the Ellicott Mills Brewing Company. They began brewing a wide range of award-winning beers and serving them up with a menu peppered with German-inspired dishes. Although the restaurant suffered serious damages in the 2016 and 2018 floods, the pub is back in business, treating customers to beer instead of boards in a building that retains much of its original rustic charm.

THE HAUNTING

Sad times often make for sad ends to the lives of people who can't bear to live through them. That seems to be the case of the ghost that many have spotted on the cavernous second-floor dining room of the Ellicott Mills Brewing Company.

It seems that sometime during the depths of the Great Depression, the financially strapped Talbotts were forced to lay off their accountant. It's said his situation was so dire that he lost his home, and his wife divorced him. He ended up living in the woods down by the mill on the banks of the Patapsco River. One weekend, a couple of the townspeople saw the accountant acting strangely, even crazy.

The police came to investigate and saw him running through the woods. They started chasing him but let him go when another call came in. Later during that long holiday weekend, others caught glimpses of him seemingly flitting in and out from behind the trees. What was he running from, and where was he going?

The townspeople got their gruesome answer and more questions on the following Tuesday, when the Talbott Lumber Company opened back up.

That morning, when the manager walked into the store, he noticed a shadow swaying in the stairwell up to the second-floor office area. He looked up to see what it was and stopped dead in his tracks. There, slightly swinging in the air in the space between the stairs and the window in an area known as "The Coffin," was the company's former accountant, hanging by his neck from the rafters.

From the condition of the body, the police determined that he had probably been hanging there since at least the Friday before. Perhaps he still had a key to the building and snuck in after the manager locked up for the weekend.

Over the decades, memories of the tragedy faded until the renovation of the building into the brewpub awakened a ghost that would become known as the "Shadow Man" as well as the specter of a little girl.

Employees at the restaurant have had a wide range of disturbing experiences. Some have been startled by the mysterious appearance of a lighted candle in the upstairs restroom. Others have heard their names whispered when they were alone in the building. A manager closing very late on a weekend reported that he heard footsteps on the second floor. The footsteps came faster and faster down the steps. The manager looked up, expecting to see someone coming around the first-floor landing, but no one was there.

Images of a man in the company of a little girl have appeared in randomly taken photographs. Is he the accountant? Is she his daughter? What binds him to this place and an unholy deed his spirit ran from—and then perhaps returned to? The answers may never be known.

FIRE STATION NO. 2

UNSEEN PRESENCES SPOOK FIRST RESPONDERS AND THE FIRE STATION DOG.

SOME SPIRITS ARE HOMEBODIES WHO can't let go of a house they loved in life. Others are so passionate about their work that they remain behind to complete unfinished business. In rare cases, the two motivations come together to bind spirits to a place that was their whole world in this life—and the next. The Third Ellicott City Firehouse, also known as Station 2, located at 8390 Main Street, is one of those places.

THE HISTORY

One of the very first buildings visitors see when driving into town from the west is the Third Ellicott City Firehouse, which was constructed on land that was part of the Rebecca's Lot land grant. Records show that Andrew J. Issac purchased the parcel of land on May 15, 1860, and that it later passed into the hands of Edward Brown. Brown sold the property to Charles T. Makinson on April 9, 1881. He built a business known as the Charles T. Makinson Carriage Factory there on the corner where Fels Lane originally intersected with Main Street.

The shop built fine carriages for more than three decades until near-tragedy struck a little past midnight on May 21, 1913, when a trolley conductor noticed flames shooting out of the back of the building. The Ellicott City Fire Company, then located at the Second Ellicott City Firehouse, just down the block at 8316 Main Street, arrived within minutes.

Even with the quick response, the fire had already spread to an adjoining grocery store where Nimrod Johnson, his wife and five children lived in an apartment above the shop. Fortunately, they all escaped the flames with their lives.

The buildings weren't so lucky. Both structures and almost all of their contents were destroyed. Neither Makinson nor Johnson carried insurance on their shops, so the charred ruins were torn down. The United Railway bought the part of the site where Makinson's blacksmith shop stood to use as the terminus of its trolley line. The rest of the property stayed vacant until 1937, when the Howard County Volunteer Fireman's Association bought "Lot 52" to build the Third Ellicott City Firehouse.

The handsome new firehouse was designed by architect Hubert G. Jory and built by Mancini Construction of Baltimore. Completed in April 1939 at a total cost of about $43,000, the Third Ellicott City Firehouse was dedicated on May 1, 1940. The spacious building had a kitchen in the basement and an office and meeting rooms on the first floor. The second floor featured an apartment for Fire Chief Benjamin Harrison "Harry" Shipley Sr., his wife, "May," and his son Benjamin Harrison Jr., as well as a dorm and locker room for the men.

Embellished with Colonial Revival details including a modillion cornice, Doric columns on the second-floor balcony and Flemish bond brickwork,

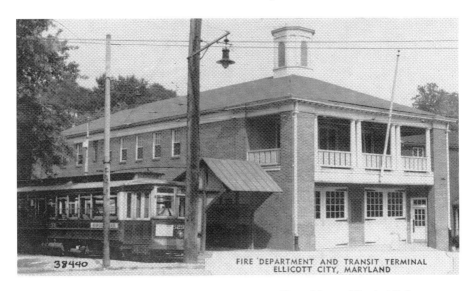

FIRE DEPARTMENT AND TRANSIT TERMINAL
ELLICOTT CITY, MARYLAND

Ellicott City Fire Department, Station 2, before 1955. *Howard County Historical Society.*

the building was crowned with a magnificent octagonal lantern. Complete with compass-headed louvered openings and a battlemented top, the lantern was designed to be a copy of the one at Doughoregan Manor.

For the next sixty-plus years, the Third Ellicott City Firehouse and its team of firefighters stood ready to put out fires in the town and surrounding area. But at the close of the twentieth century, sometime in early 2000, the fire company moved once again to its newest firehouse on Montgomery Road.

In 2002, the old building was sold to Main Street F.H. for the sum of $795,000. Seeing the building's potential, the company turned the old firehouse into retail space below and offices above.

The first store to open there was a second location of the Regency Antiques shop in Baltimore. In 2008, a new tenant, the Wine Bin, took up residence in the first floor and basement of the old firehouse, where it sells fine wines, specialty beers, craft liquors and cigars, as well as food- and drink-oriented gifts and tableware.

The Haunting

Other than the Johnson family's narrow escape from the devastating fire of 1913, it doesn't seem that anything tragic actually happened at the old firehouse. However, over the course of sixty years of racing to the scene of often deadly fires, perhaps some of the souls who perished in them may have hitched a ride back to the station with the firemen. Or, maybe, as some say, a few former residents never left.

The stories of odd happenings at the firehouse are well known in the community. It didn't take long before new firefighters and volunteers assigned to Station 2 started sensing ghostly presences. The television in the men's dorm area would often mysteriously flicker to life by itself at the strangest times. Heavy chairs would glide across the floors, pushed by an invisible hand. When these stories were shared with their fellow firemen, the old hands would silently nod their heads and shrug. Things were always going bump in the night at the firehouse. You just had to live with it.

But some people couldn't. One firefighter found the occurrences so unnerving, he refused to stay in the firehouse alone during the day and never at night. The crew would always find him outside smoking after they came back from a call.

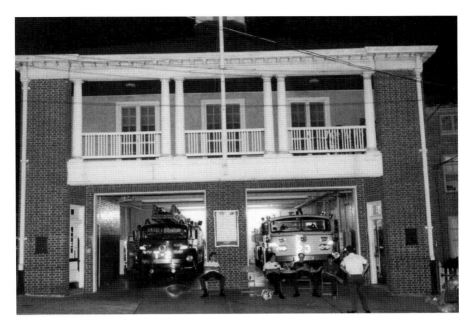

A 1970s view of Ellicott City Fire Department, Station 2. *Dale Gardner, Battalion Chief (Ret.), Howard County Fire and Rescue.*

When an alarm came in, after the engine would scream out of the garage doors, the ghostly inhabitants would begin to stir. Volunteers left behind to man the station sometimes reported sounds of silverware rattling down in the cavernous basement where the kitchen was located. Other times, they heard the distant clacking of an old-fashioned typewriter in the office area above.

When the crew went out on a call and no one was available or wanted to stay behind, they would lock up the station tight as a drum. When they came back, they found all the doors unlocked. It happened so often that, at one point, they went as far as changing all the locks in case someone had gotten hold of a key and was playing a prank on them. No such luck. Even after they were changed, the locks continued to open by themselves when the firefighters were away.

One particularly hair-raising story goes that while the firefighters were watching a football game on a Sunday afternoon, Yogi, the station's fire dog, went on high alert. His ears perked up and he sat bolt upright. The agitated dog's eyes were riveted to the door and then seemed to follow the progress of someone or something walking through the door and down the hall toward

Ellicott City Fire Department, Station 2 mascot Yogi in "full gear." *Howard County Historical Society*.

the apartment where the long-dead Fire Chief Harrison Shipley Sr. and his family once lived.

At that point, Yogi ran down the hall and began frantically barking and clawing at the door. The men rushed after him and opened the door to the apartment. There was nobody there. Whatever had walked down the hall and through the closed door had vanished.

Indeed, the paranormal experiences have long been attributed to the ghost of the former fire chief, Benjamin Harrison Shipley Sr., who served and lived at Station 2 from 1935 to 1957. Born in 1891, the former auto mechanic turned volunteer firefighter died in September 1967 at the age of seventy-six. In 2002, Harry Shipley Jr. joined his father in the afterlife and perhaps at the fire station as well, at the age of eighty-eight. The ghost or ghosts didn't leave when the firemen moved out.

Dave Carney, the owner of the Wine Bin, which opened in 2008, said, "I could feel the Captain [Chief Shipley] as soon as I entered the store. I felt that he was far from threatening. In fact, from stories that I heard on the Spirit Tour, he seemed quite playful. It's obvious that the Captain loves his Fire Station home and he shares it with the current owners."

On one occasion, the ghosts decided to make themselves known in a definitive way. Carney reports that he once "captured a photo with four 'orbs,' so obviously, Shipley is not alone. I'm certain that one of the orbs was a former firehouse dog."

So, who knows? Maybe Yogi finally caught up with the figure he saw walking down the hall and stayed behind to keep the Shipleys and the other firehouse phantoms company.

11

THE JUDGE'S BENCH

WELCOME TO THE BAR WHERE EVERYBODY KNOWS THE GHOST'S NAME.

THERE MUST BE SOMETHING ABOUT spirits that attracts "spirits," because there are an awful lot of bars in Ellicott City that have resident ghosts. None is more famous than "Mary," who is said to be responsible for a wide variety of mysterious happenings at one of the town's oldest neighborhood bars, the Judge's Bench.

THE HISTORY

Tucked into the hillside on the south side of far upper Main Street, this stone and siding-clad building at 8385 Main Street stands on what was originally part of the Mount Misery land grant patented to Thomas, Elias and William Brown in the 1700s. The Browns owned it until 1819, when they sold it to Irvin McLaughlin.

Little is known of what was or wasn't built on the property in the thirty-four years between the time McLaughlin bought it and when he sold it to twenty-seven-year-old Sophia Frost in 1853 for the sum of $390.

Sophia and her husband, Elias W., may have built the house, which is said to date to sometime before 1878. At the time of the 1880 census, the couple—along with their daughter Olivia—lived at that location, which was described as a "confectioner's store."

The building on the left is the Judge's Bench. Open windows on the third floor are near where a young girl is said to have hanged herself. *Howard County Historical Society*.

The building and the business remained in the Frost family for nearly one hundred years until sometime in the 1940s, when Russian-born immigrant Joseph Berger and his wife, Mary, purchased the property. They opened a small grocery there called Joe Berger's Grocery, which served the residents of Ellicott City for at least two decades. After the Bergers left in the 1960s, Bode Floors had a showroom there.

In the 1970s, the building transitioned into its current incarnation as a bar called the the Judge's Bench. According to local lore, the name comes from the fact that during the blistering days of summer in the 1800s, lawyers and judges working at the original stone courthouse, which was destroyed by the 2018 flood, would stroll over to Frost's between cases and enjoy a cold beverage on the tree-shaded benches in front of the store.

Today, lawyers and judges try their cases at the impressive stone courthouse up the hill. But they often come down to the Judge's Bench, the neighborhood bar that serves up beer, whiskey and tasty pub fare as well as persistent stories of paranormal experiences that unnerve waitstaff and guests alike.

THE HAUNTING

Although the paranormal activity at the Judge's Bench is reported to be fairly benign, the circumstances that may have caused the spirit of a young girl to remain in the building are anything but.

The year was 1962. At that time, the Bergers and their daughter Mary were living on the second floor of the bustling grocery store in the historic stone building at the corner of Main and Hill Street.

Old-timers will remember that Ellicott City wasn't always the gentrified tourist town it is today. In the 1940s and '50s, the town's rowdy bars, crime and prostitution caused it to be declared off limits to military personnel at Fort Meade. It was a rough neighborhood. Naturally, the Bergers wanted to keep a close eye on their beautiful teenage daughter, who served their customers at the small grocery store.

The legend says that her parents forbade Mary from dating any of the boys who lived in Ellicott City. She followed the rules through high school, but shortly after she graduated, she fell in love with a young man from the town. The Bergers were furious. Despite her assurances that he was a good, kind, respectable boy, they made her cut off the relationship.

Brokenhearted and distraught, it's said that Mary waited until after the store closed for the night and her parents were away. She climbed the stairs to the third-floor attic of the building, threw a rope over a rafter and hung herself. She was just nineteen years old.

The ghostly sightings began shortly after she was buried. Customers reported seeing her apparition at the store. Sometimes they thought they caught a glimpse of her behind the counter. At other times, people walking past the building at night would see a ghostly face with haunted eyes peering out of one of the attic windows. Later, when the building was purchased by the first owner of the Judge's Bench bar in the 1970s, construction workers renovating the space reported seeing a young woman who, on second glance, would disappear.

Mary's ghost makes her presence known throughout the building, but her spirit is most active on the third floor, where the hanging took place. Over the years, there have been many accounts of liquor bottles falling from behind the bar. One time, one of the bar owners said he opened one morning to discover whiskey bottles neatly lined up on the floor behind the bar.

According to Buzz Suter, who bought the pub in 1992, the staff had experiences with the restrooms—toilets would unaccountably flush on their own, faucets would turn themselves on and an entire roll of toilet paper once

unrolled itself while no one else was in the bar. Another owner reported that, while working on the building's third floor, she was shocked to feel a cold breeze but could not locate a source.

Strangest of all, one of the bartenders who used to work at the Judge's Bench claimed that he often spoke with Mary. It's said that most of the waitstaff wouldn't go downstairs, because the ghost would appear down there. But for some reason, catching sight of her ghostly form in the dim corners of the basement didn't bother the bartender. He said he had fallen in love with the spirit of the young girl. So, if only for a short time, it seems Mary finally may have gotten her Ellicott City boy.

HOWARD COUNTY WELCOME CENTER

A SINGLE SPIRIT REMAINS AT A SITE WHERE THOUSANDS BEGAN THEIR JOURNEY TO THE GRAVE.

TOURISTS WALKING THROUGH THE DOORS of the Howard County Welcome Center at 8267 Main Street might have an inkling that the building once was used as a post office. However, they probably have no idea what once stood on the site of the handsome stone building they see today. If they did, it might explain the odd sounds, strange sights and cloying smell that visitors, Ellicott City residents and Howard County Tourism employees have been experiencing for years.

THE HISTORY

Perfectly situated at the top of Main Street, the Howard County Welcome Center wasn't always a place for visitors to pick up pamphlets or duck into one of the town's only public restrooms. The massive stone building that looks like it's always been there was erected on land where the homes of Mr. Hamilton, Mr. Treakle and Mr. John Forrest stood in 1839. A few decades later, those homes were replaced in part by the W.J. Bewley Funeral Home that fronted on Main Street and the Gaither Livery Stables, owned by Thomas Jay Gaither and located around back.

William James Bewley and his older brother Lemuel ran the W.J. Bewley Funeral Home on the site for a number of years until William's death on December 11, 1872, at the young age of thirty-eight.

The building and the undertaking business were then sold to Stephen Jones Hillsinger the next year. Despite its line of business, the Hillsinger Undertaking Parlor was a very long-lived enterprise on Main Street—and so was its owner. In 1920, two years before he died on Halloween night at the age of eighty-one, Hillsinger was still listed as working as an undertaker. Newspaper accounts of his death said he had been taken to Johns Hopkins Hospital to be treated for "blood poisoning."

The business apparently continued after the death of Stephen Sr.; in 1937, an appropriation of $90,000 was made in the Construction Act to purchase a site and build a new post office in Ellicott City. According to records, the site chosen at the corner of Main and Hamilton Streets was occupied by "several dwellings, Stephen Hillsinger's Undertaking Parlor, a livery, and apparently, a wagon and carriage manufactory with a blacksmith's shop attached at the rear."

After the existing structures were torn down, the new post office was built. When finished and dedicated in 1940, the handsome one-story squared rubble stone structure featured a public lobby with five windows for patrons, an alcove with two hundred lockboxes, the postmaster's office

Site of the former Ellicott City Post Office; this building is now the Howard County Welcome Center. *Shelley Davies Wygant.*

and a large workroom behind the patrons' windows on the first floor. At the time, offices for the county agent and the home demonstration agent were in the basement.

The post office served Ellicott City residents for almost sixty years until a new post office was built near Route 40. Howard County purchased the building in 2008 and turned it into the Howard County Welcome Center. In 2011, after spending many years in the basement of the post office, Howard County Tourism Inc. moved upstairs, where it shares the first floor with the Ellicott City office of U.S. congressman Elijah E. Cummings. The basement offices are now home to the Howard County Police Museum. Although the building was closed for repairs after the floods of 2016 and 2018, it was not damaged. Today, it welcomes visitors and Ellicott City residents who come to find out about area happenings and whisper about what they've seen and felt in the building.

THE HAUNTING

It should come as no surprise that a building constructed on the site of a funeral home that spent nearly seventy years helping usher hundreds if not thousands of Howard County's dead into the afterlife would be haunted by the spirits of at least one of them.

According to employees and visitors, incidents of unexplainable phenomena are quite common. Among the most noteworthy are ghostly sightings of a young woman who seems to desperately want her existence to be acknowledged and her name to be known.

In the winter of 2004, when the center was still the Ellicott City Post Office and the tourism offices were in the basement, one of the staff heard something heavy being dragged across the floor above her. At first, she thought it might have been a postal employee pushing a crate into the mail room, but then, with a shudder of realization, she remembered that the office had closed hours ago. No living being had made those sounds.

Others reported the rattling of a certain storage room's doors. The sound would stop before the staff could get there to check it out. Then, almost as soon as they returned to their work, they would begin to hear a thumping sound like that of a heartbeat coming from the empty room they had just left. Once, staff members unlocked the door to the copy room and were shocked to see that a set of shelves that had been bolted to the wall at one

end of the room was now at the other end, with every item on them still neatly in place.

Another time, an employee heard the unmistakable sound of high-heeled shoes on hardwood flooring coming down a hall that was carpeted at the time. This same staffer had dismissed her coworkers' ghost stories "until one day I was sitting in the back room talking to a coworker, gossiping, and I heard and felt someone lean in [to my left ear] and shush me and honestly, I got chills."

Sounds aren't the only indication that the ghosts of Hillsinger's dead still roam the site of the old funeral parlor. The same staff member also noticed a scent. It was the sweet and unmistakable smell of funeral flowers. Ed Lilley, the center's manager and a longtime resident of Ellicott City who seems to have a special affinity for the spirits that inhabit the town, also smelled it. Strong and persistent despite all the office doors being open, the scent hung in the air of the back hall and in the conference room. More than once, ghost tour guests who hadn't yet been told about the center's history whispered to the tour guide that the office smelled like a funeral home. They would soon find out why.

When the ghost finally appeared, it was after the post office closed and the tourism office moved to the main floor of the building. Naturally, Ed was the one who saw it. He caught sight of the spirit one night when he was working late, long after he had locked the center's heavy doors. He was sitting behind a desk near the ticket counter when he got a strong feeling that he was not alone in the room and that, in fact, someone was standing in front of him.

Startled, because he thought he was there by himself and hadn't heard anyone come in, he looked up from his work. There she was. Although he saw her for only a few seconds, his description couldn't be clearer or more precise. Standing at the end of the brochure rack was a woman. She looked like she was probably in her mid-thirties. Her long brown hair flowed down around the shoulders of her white dress with a high, standup collar. Almost as soon as he saw her, the woman vanished—but not for good.

When he shared his sightings with other welcome center staff members, Ed wasn't surprised to find that many of them had felt her presence and that at least one had seen her strolling through the back hall of the office. They reported that they felt a cold spot near the ticket counter.

Caught up in the recounting of their supernatural experiences, the staff decided she needed to have a name. As soon as the suggestions started flying, the lights in the center began to flicker. Undaunted, the naming debate continued until it was interrupted by the ringing of the phone on the front

desk. When Ed picked it up, there was no one on the line. Convinced that they had summoned the woman's spirit, the staff members quickly wrapped up the naming session and decided that they would call the ghost Caroline. That settled the matter for the moment, but the ghost remained restless.

Perhaps she wasn't satisfied with the name. The staff continued to hear odd noises, catch the sickening scent of funeral home flowers and feel the paranormal presence of the spirit they had so hurriedly named. The mystery cleared, or deepened, one afternoon when a visitor came to the tourism office to buy a ticket for the ghost tour later that evening and got a strong sense that an unseen entity was desperately trying to communicate with her. She revealed what the spirit had been trying to tell her to the staff member who checked her in when she came back for the tour that evening.

It seems the ghost wanted to let the staff know that her name wasn't Caroline but, rather, a name that began with the letter *L*. As she thought more, she said she felt like the name was something like Loretta, Louise or Louisa. On that day, the name "Caroline" died and was replaced by the ghost known today as Louisa.

Mumbles & Squeaks Toy Shoppe

THREE SIBLINGS TAKEN BY TYPHOID STAY BEHIND TO PLAY IN A FORMER TOY STORE.

DURING THE YEARS OF THE Civil War, typhoid fever, the "miasmatic" infectious disease transmitted by contact with what doctors back then called "an unknown poison" in the air, regularly spirited away thousands of Marylanders. Ellicott City lost its share of residents to the sickness that caused skin lesions called "rose spots," diarrhea or constipation, fatigue, respiratory distress and fever.

With a fatality rate of 60 percent in 1864, typhoid fever was basically a death sentence for anyone who contracted it. Among them may have been three young children who, legend has it, remained behind to keep each other company in the attic of their two-and-a-half-story granite home in the center of town.

THE HISTORY

Constructed of locally quarried granite, this sturdy stone home located at 8133 Main Street is part of what was known in 1836 as "George Ellicott's Lot." The land was left to George Ellicott Jr. by his father in 1832 and was deeded to him by his mother, Elizabeth, in 1834. George Jr. was a dutiful son, so he built a double stone house on the property, as his father wanted him to.

William H. Fissell grocery store and future home to the Mumbles & Squeaks Toy Shoppe.
Library of Congress Historic American Buildings Survey.

In 1860, the building was sold to German-born Joseph Merkle for $800. Records at St. Paul's Catholic Church in Ellicott City show that Joseph married Elizabeth Henke sometime between September 1858 and January 1864, so it may have been their first home. In 1887, the east side of the building was home to a carpet-weaving shop, while the west side remained a residence.

Over the years, a variety of businesses opened shop at 8133 Main Street, including Fissell's Grocery and a Chinese laundry. In 1992, Ed Williams and Frank DiPietro opened a shop filled with all kinds of old-fashioned toys and games.

In 2013, Craig Coyne Jewelers moved to the building from its original shop down the street and remained there until the disastrous flood of July 30, 2016, inundated the shop and washed $500,000 of upscale jewelry into the Patapsco River. After the 2016 flood, a retail store called Culture Lab opened on the site. It closed and relocated after the 2018 flood. At the time of this writing, the future of the building is unknown.

THE HAUNTING

Future residents may have company at their tiny stone store, at least according to the ghost story that tells of three young siblings who all died of typhoid fever there in the cold, damp spring of 1864.

Perhaps because they were so young and died so close to the same time, they met each other in the mists of the near-afterlife and decided not to cross over. Instead, they chose to stay with each other in the upstairs bedroom where their mother had nursed them and helplessly watched them slip away one by one.

Their parents, who may have been Elizabeth and Joseph Merkle, eventually moved away, leaving the children's spirits to fend for themselves. The story, told from the perspective of the children—identified as Sean, Lissa and their four-year old brother, Colin—says that they were especially delighted when the toy store opened. It's said they would creep down the stairs at night to play with the toys and warm themselves by the embers of a phantom blaze in the fireplace that late-night passersby sometimes thought they saw flickering through the shop windows. Then, as the faint morning sun began streaming through the windows, they would ascend the stairs, dissolving into three small orbs of blue light that pass through the ceiling and into the attic above.

Maybe these three children lost in the limbo between this life and the next tried to communicate with the shop owners, who dismissed their voices as "mumbles" coming from the shop next door and their footsteps as "squeaks" from the settling of the ancient floorboards. That's one explanation for the name of the long-closed Mumbles & Squeaks Toy Shoppe.

RICHARD PARTINGTON HOUSE

A SPIRIT MAKES HER PRESENCE KNOWN IN A BLOOD- AND PAINT-SPATTERED FORMER BUTCHER SHOP.

ONE OF THE FEW STONE structures on Main Street whose exterior remains unchanged from when it was built, the four-bay-wide home at 8081 Main Street retains much of its colonial-era charm. Until the 2018 flood, the old home welcomed visitors who wanted to pass a relaxing afternoon sipping a cup of Earl Grey in a Victorian tearoom, not realizing they may have been in the presence of a violent ghost who can't seem to find peace.

THE HISTORY

The little stone house near the foot of Main Street has a long and interesting history, which begins in 1833, when Samuel Ellicott leased part of Lot 10 of the 1830 Ellicott partition to Richard Partington. He likely bought the property, because shortly afterward, he built the granite stone house that still stands on a sliver of land on the banks of the Tiber.

Six years later, in 1839, the home began its life as a commercial establishment when Baltimore merchant Selman Crooks bought the property for $1,500. In 1849, John Collier ran a shop at the site that sold stoves, ranges and tinware. He is listed as living there and running the store in the 1860 U.S. Census, along with his wife, Rebecca, and sons George and Frank. He died the next day, on July 29, 1861, at the age of sixty-six.

The Richard Partinger House, later home to Kraft's Meat Market, Evelyn's Beauty Salon (*shown*) and Tea on the Tiber. *Howard County Historical Society.*

Twenty years later, in 1881, Dorothy Kraft purchased the shop for $1,500 shortly after her husband, Andrew's, death on New Year's Day of that year at the young age of forty-two.

The Kraft family were Howard County's most successful butchers. Both Dorothy and Andrew had immigrated from Germany, then met and married here in the United States. The large and prosperous Kraft family lived in a sprawling frame house they built on Old Columbia Pike in the 1860s with their ten children and other family members. Now Slack's Funeral Home, the property was used for the Kraft's business as well as their residence, as they did the butchering for their Main Street shop behind the house. Sometime after Dorothy died in 1916, the Kraft heirs sold the property; later, it reportedly became home to a doctor's office.

The owners of the charming stone building on Main Street came and went over the years without much notice, until it, along with the other buildings on lower Main Street, was damaged in the devastating 1972 Hurricane Agnes flood. Fortunately, the building, which may have been owned by John Josselson at the time, remained standing. Josselson sold it to Charles W. Anderson in 1981.

Businesswoman and real estate investor Dorothy Kraft was the richest woman in Howard County when she died in 1916. *Howard County Historical Society.*

About that time, Bill Andrews and his wife, Barbara, moved their interior design business to the building from the Mall in Columbia. Known as the Source Unlimited, the shop provided Ellicott City–area homeowners with decorating services until the early 2000s. In 2004, they opened Tea on the Tiber, a Victorian tearoom and gift shop.

Sometime in 2012, the Andrewses sold the business to Linda Jones. In 2015, Anderson sold the building itself to Master's Ridge LLC for $550,000. A little more than six months after the sale, the catastrophic flash flood of

July 30, 2016, roared through the first floor of the building, causing $50,000 in damage. The business closed for a complete renovation, reopening exactly six months and ten days after the flood; it was flooded again in 2018. At this time, the future of the business and the building is uncertain.

THE HAUNTING

Over the course of its long history, the little stone house that backs up to the Tiber River has seen its share of sorrowful experiences, including one in its own attic.

It seems one of the building's many recent renovations awakened something in the old stone house one night after Andrews had locked up and gone home. Whatever it was had obviously flown into a rage, because when they walked into one of the rooms they had been working on, there was blood-red paint splashed everywhere. There were spatters on the ceiling, and long streaks ran down the walls. The floor was covered in sticky redness.

Their first thought was that vandals had broken in and caused the damage. But there were no signs of forced entry. Whoever had done it had been inside the building when they left the night before.

When Bill and Barbara realized that the culprit couldn't have possibly gotten out since all the windows and doors were locked tight, their eyes widened in fear. The person or persons who had splashed the paint had to still be there.

Now angry, the Andrewses frantically searched the building top to bottom but found nobody there. However, a few weeks later, they found something else. A longtime Ellicott City resident gave them a possible explanation for the paint incident and the objects that kept disappearing and reappearing later in the shop.

It seems that a few decades after the building was a butcher shop, where the flesh of freshly slaughtered hogs was hung, there was another hanging. A woman by the name of Kathryn had hung herself on the second floor and was probably trying to make her presence known.

After much work, the shop owners eventually cleaned up the evidence of the ghost's anger, but they said they couldn't get rid of the spirit who still occasionally reminds them that she's there, fortunately in less violent ways.

EASTON SONS FUNERAL HOME

AFTER NEARLY TWO HUNDRED YEARS, UNSETTLED SPIRITS ARE FINALLY LAID TO REST.

WITH ITS DESIGNATION AS ONE of the most haunted towns in America, it should come as no surprise that Ellicott City has been home to more than its fair share of funeral parlors. Among them is the Easton Sons building at 8059 Main Street and the funeral home's livery stable behind it at 8061 Tiber Alley. Strange scents, a menacing milky-eyed specter and a nearly hidden horse-drawn hearse hint at the presence of spirits lingering at what was once one of the town's most popular coffee shops and an alleyway antiques store.

THE HISTORY

Although the current building, with its distinctive Gothic arch windows on the first floor and "Easton Sons" carved into its granite façade, was built around 1930, the history of the property goes back to the early 1800s.

In 1858, it was home to Bernard Fort's sprawling cabinet and coffin shop complex that ran down the south side of the road to 8049 Main Street. In 1880, German-born grocery shop owner and saloon keeper Daniel Laumann, along with his son-in-law Clinton M. Easton, purchased the frame building, as well as the stable behind it, to open a funeral parlor.

It's said that in those days, when someone died in the rural part of the county, a relative would ride into Ellicott City on horseback with a stick

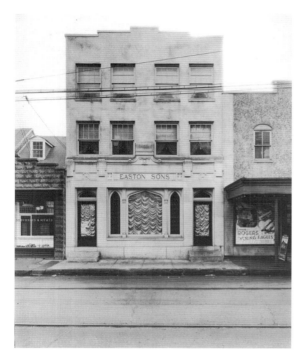

Left: Easton Sons Funeral Parlor was located next to Earle Theatre movie house, which burned down in 1941. *Howard County Historical Society*.

Below: Family members could choose from a wide variety of caskets, both child-sized and adult, in the Easton Sons display room. *Howard County Historical Society*.

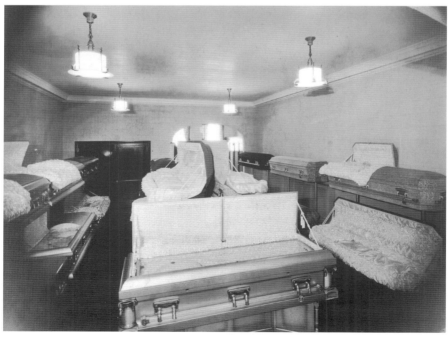

notched to indicate the height and width of the recently departed. The undertaker would use these rustic measurements to let the cabinetmaker know what size coffin he needed to build.

It appears that Clinton Easton died before the turn of the century, because the 1900 U.S. Census lists Annie Easton as widowed and running the funeral parlor along with her sons Milton and Daniel.

Young Milton seems to have taken the lead in running the business despite some health problems. Just five feet, two inches tall, he was disqualified for military service in 1918 "due to asthma and being kicked by a horse." His granddaughter remembers him as always having candy in his pocket for children and greeting people on the street with a cheery, "How 'do!"

By 1930, the Easton Sons funeral parlor was doing well enough that it could afford to tear down the original frame building and build a handsome three-story stone and masonry building. The first floor housed a chapel, while the embalming room was located at the back of building on the second floor. At the front of the building was a visiting room as well as a "repose" room. Mourners who were overcome with grief could take refuge

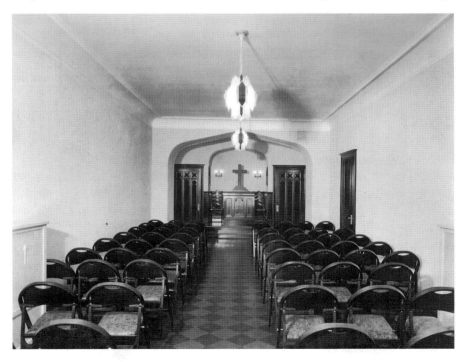

Mourners attended funeral services in Easton Sons' one-hundred-seat chapel. *Howard County Historical Society.*

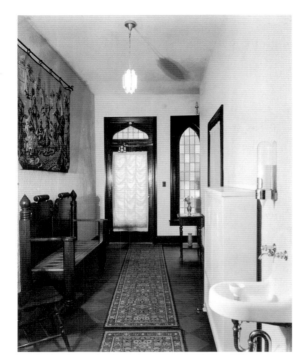

Left: The newly bereaved entered Easton Sons' reception area through the front door located on the right side of the building. *Howard County Historical Society*.

Below: Caskets were conveyed to the viewing room via the only elevator in Ellicott City, which arrived behind the double doors shown here. *Howard County Historical Society*.

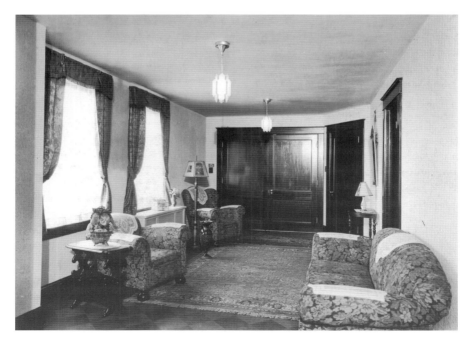

in this purple-carpeted sanctuary and lie on a small bed covered by an orchid spread or, if they fainted, be revived by smelling salts. In addition, the building had a large double-door elevator to transport bodies up to the embalming room and then down to the chapel and out the back door to the waiting hearse.

In the earliest days of Easton Sons, the departed were transported to their final resting place in an ornate horse-drawn carriage. Later, Easton Sons had a fleet of luxurious motor-coach hearses that, probably to the dismay of the injured they transported, were also used as ambulances until 1957.

The story of Easton Sons funeral home on Main Street ended after nearly seventy years when the business closed in the 1950s after Milton's death in 1948. A fire in 1965 destroyed the front portion of the third floor of the building.

In 1968, Ed Crowl transformed the old livery stable into the Wagon Wheel Antiques Shop. Packed floor to ceiling with antiques and collectibles, the shop's most notable treasure is Easton Sons' 1850s horse-drawn hearse. Although it's in a slight state of disrepair and was damaged when the building's roof collapsed from the weight of snow that fell during the winter of 2010, the still magnificent hearse remains on display on the second floor of the building.

The dead traveled in style in Easton Sons' 1920s hearse, photographed on the grounds of Rock Hill College. *Howard County Historical Society.*

Subsequent businesses at the former Easton Sons funeral parlor included a laundromat, a photography studio and the SHK Art Gallery, as well as a pizza and sub shop called Grinders. In 1993, Jill and Michael Lenz opened Riverside Roastery & Espresso. Four years later, in 1997, Gretchen Shuey, a former Riverside Roastery employee, took over and renamed the shop Bean Hollow. It served coffee, food and ice cream without incident for nearly twenty years until the first floor of the building was severely damaged in the catastrophic flash flood of July 30, 2016. Video surveillance footage of the event shows employees frantically rushing to escape the muddy water that poured into the shop. Fortunately, no one was injured, and the restored and rejuvenated Bean Hollow reopened shortly after the one-year anniversary of the flood. Unfortunately, the flood of 2018 sounded the death knell for the shop. Shuey plans to relocate to nearby Catonsville.

Today, the future of the Easton Sons building is unknown, as is the fate of the old livery stable/antiques store that displays the horse-drawn hearse on the second floor. More than half a century after the last procession left the cool, lily-scented rooms of one of Ellicott City's oldest funeral homes, something or someone remains to let the shop owners, visitors and residents know that the past continues to live on.

THE HAUNTING

Although the best-known stories about the spirits at Easton Sons come from the owner and employees of its most recent incarnation as a friendly neighborhood coffee shop and café, there is one account of a woman who visited the building many decades after the funeral parlor had closed and had absolutely no knowledge of the building's grim past.

The minute she stepped through the door, the woman suddenly stopped. Her eyes widened and searched the room as if trying to remember something.

"That smell…," she said.

"What smell? Is it musty or damp?" her companion asked.

"Formaldehyde," she said as she turned on her heels and fled the building, never to return.

Although the unsettling scent of embalming fluid has long since been replaced by the inviting fragrance of roasting coffee beans, other evidence of the building's past use and inhabitants remains.

Bodies of the recently deceased were prepared for viewing in the tiled embalming room. *Howard County Historical Society.*

Floors have been mysteriously mopped up. Coffee has been brewed and ready to serve long before the first employees reported to work. But not all of the happenings have been helpful.

Shortly after the most recent coffee shop opened, the owner repeatedly noticed money missing from the cash register. Concerned, she set up a video camera to identify the culprit. When she played the recording, she saw all her employees dutifully close and lock the door behind them. Now witness to an empty store, the camera continued to run. After a few moments, the murmurings and whisperings began. She heard random words, footsteps and shuffling, but the cash register was left untouched.

On another occasion, the master menu for the café came up missing. The owner tore apart the shop looking for it. She had always kept it tucked under the cash register, but now it was gone. Resigned to its loss, she put together a replacement menu and tucked it into its customary place under the register.

Just as she was turning away, she caught a movement out of the corner of her eye. In the absolute stillness of the shop—no breeze or gust of wind

from an open door—she watched as the new menu was slowly pulled out from beneath the register, fell to the floor and was whisked beneath the dairy refrigerator.

She immediately fell to her knees to retrieve the replacement menu, which was tucked underneath the case along with the original menu. These experiences, as well as others involving mugs mysteriously moving from the shelves to a countertop in the dish room, made her look into having the building spiritually cleansed.

The woman she found to shoo the spirits away walked through the narrow coffeehouse for about a half hour with a candle, a hawk's feather and a smoldering bunch of sage. She said she saw an apparition of a woman in a floral dress standing outside the shop. She appeared to be a servant of some kind and was apparently inviting "vagrant" spirits into the coffee shop to do their mischief. The spiritual cleanser told the all-too-hospitable spirit to stop inviting other ghosts in and that the spirit was free to leave this world. After the cleansing, the odd occurrences seemed to cease.

Whether the murmuring mischievous spirits are the dearly departed from Easton Sons funeral home or long-dead vagrants looking for a cozy place to warm their bones, the ghosts of the coffee shop may be gone, but they will never be forgotten.

PHOENIX EMPORIUM

FLOODS, FUNERALS AND FALLING ROCKS FILL POPULAR WATERING HOLE WITH RESTLESS SPIRITS.

CURRENTLY HOME TO THE PHOENIX Emporium bar and restaurant, the frame and brick building located at the corner of Maryland Avenue at 8049 Main Street has seen its share of Ellicott City tragedies. Whether its otherworldly inhabitants are the remnants of lives lost in its construction or the victims of the great flood of 1868, the bustling bar is said to be stocked with more than distilled spirits.

THE HISTORY

The land and the part of the Tiber River that the current building was erected over was vacant at least until 1850, when it was purchased for Hester Ann Rogers Putney, who leased it to Howard Swain for sixty dollars a year. Swain, who had set up an office in the B&O Railroad depot, used the empty lot to sell lumber, lime and coal.

Between 1858 and 1887, the Bernard Fort family operated a cabinet shop on the site. A January 1, 1850 newspaper advertisement signed by William Fort said that the business's undertaking department "is prepared to furnish, at a few hours notice, in the village, or surrounding country the best finished Coffins." After 1887, records variously show that there was a one-story grocery store and/or a saloon run by John O'Brien on the corner at the center of town.

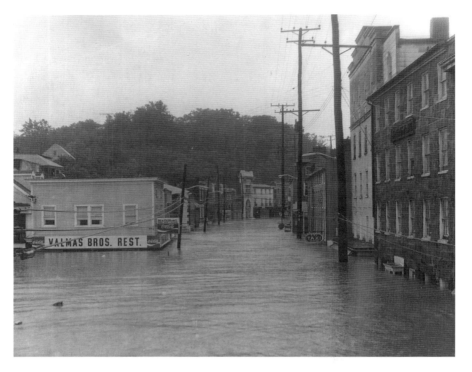

Pictured during the 1972 Hurricane Agnes flood, the Valmas Bros. Restaurant building stands on the original site of Fort's cabinet shop. *Howard County Historical Society.*

A second story that housed living quarters was added to the building in 1925. Over the years, a number of businesses were located at the corner of Main Street and Frederick Road, including bars and restaurants operated by the Fissell and Valmas families. A few years after the devastating Hurricane Agnes flood in 1972 and the Hurricane Eloise flood of 1975, the Valmas family sold their restaurant to a husband, his wife and their son-in-law. The trio began fixing up the property, which they planned to call the "Maryland Inn." Unfortunately, the husband died during the renovations, and the business never opened.

In 1978, the property went up for auction. George Goeller was the high bidder, beating out Dr. Irvin Taylor and Sam Caplan with a bid of $10,000 for the deposit. He named his new bar the Phoenix Emporium in honor of the rebirth of the town after the floods. The building was inundated and damaged in both the 2016 and 2018 floods.

The Haunting

It's possible that one of the reasons the land that the Phoenix is built on stayed vacant for nearly one hundred years after the town was founded is that it's a tricky piece of property—it is basically made up of the fast-flowing water and banks of the Tiber Branch.

According to legend, it's said that the first life lost at the site was a man involved in the construction of the building in the mid-1800s. Because of the lot's challenging terrain, a retaining wall had to be built to shield the structure's basement from the rushing stream beside it. Huge stones that may have been gathered from the riverbed were used in the construction of both the retaining wall and the foundation. Apparently, while laying the foundation, a large portion of the massive wall collapsed, crushing one of the workers to death.

That first death was followed by a host of others in 1868, when a massive flood tore through the Patapsco River Valley. Fourteen houses along the river and millrace were destroyed by a wall of water. *Harper's Weekly* reported that the Patapsco River at Ellicott "rose ten feet before a drop of rain had fallen there, and was at one time forty feet high!" That account may have been sensationalized, but it was far and away the worst flood in the history of Ellicott City.

Since the families living along near the Patapsco River had dealt with frequent flooding, they didn't leave their homes when the water started rising. Instead, they climbed to the upper floors and eventually onto the roofs of the buildings. Residents watching the horror from the town's many hills reported hearing the screams of terror from the men, women and children trapped by the raging waters—at least for a while. At some point during the rain-drenched afternoon, the monstrous power of the flooding water combined with tons of floating debris and the remains of the Granite Factory that had collapsed not far upstream silenced their screams as it pulverized homes and swept more than three dozen souls to their deaths in the Patapsco River.

At the time of the flood, the structure housed the cabinet-building shop of Bernard Fort. In addition to cabinets and furniture, Fort also built coffins. It's said that many of the bodies of the drowned townspeople that were recovered far downstream on the Patapsco were brought to Fort's shop to be identified and fitted for coffins. How many bodies or how long they remained in the building isn't known. But one thing seems certain: at least something of them stayed behind after their coffins were carried out and laid to rest in local cemeteries.

Over the years, employees have reported sightings of an apparition described as a Civil War soldier in the basement. Others have seen a man dressed in a nineteenth-century frock coat lurking in the cellar's dark shadows who vanishes when noticed. One waitress said she saw what she described as "smoky wisps" upstairs as well as in the lower level. They hovered above her head, and she felt a presence. Then the wisps started moving with what seemed like a purpose, as if they were passing into another dimension.

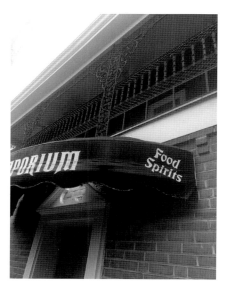

Today, the Phoenix Emporium serves up spirits of all kinds. *Shelley Davies Wygant.*

Other ghostly encounters have been even more unnerving. While working alone one day, one of the bartenders heard someone say, "Hey, how are you?" When she turned to reply to the friendly greeting, no one was there. Another time, this same employee was jolted by the sound of plates crashing to the floor. When she whirled around to look, she saw a pile of broken plates and a few of the bowls still spinning on the floor… of the empty kitchen. There are also tales of banging phantom pots, a hanging tip bucket swung by unseen hands and the frequent murmurings of faraway voices.

Are they the voices of the drowned dead pulled from the river and laid out in coffins at Fort's cabinet shop? Is the shadowy man in the basement a fallen Civil War soldier who wandered over from the train station? Perhaps the "smoky wisps" represent the spirit of the man suddenly crushed by a stack of falling stone who, after more than 150 years, still doesn't realize he's dead. Whatever the identities of these apparitions and manifestations, the dead seem destined to remain to mingle with the employees and patrons of one of the liveliest pubs in town.

EDWARD T. CLARK & SONS

GHOSTS SHARE SPACE WITH TIMELESS TREASURES IN THIS FORMER FEED STORE.

HOME TO ONE OF ELLICOTT City's oldest continuously operating businesses, the rambling store, former coal yard and livery stables located at 3720 Maryland Avenue have been a fixture since the mid-1800s. Today, shelves that used to be filled with farm supplies are now crowded with every vintage thing you can imagine in the building's current incarnation as an antiques mall. The store provides shoppers with hours of browsing pleasure as well as an occasional glimpse into the afterlife. Some of the ghosts are playful. Others are merely mysterious. But one has an eye for evil that threatens to drown those who look at him in the depths of dread and sorrow.

THE HISTORY

The land where the Edward T. Clark & Sons farm supply building stands was vacant at least until 1850, when it was purchased for Hester Ann Rogers Putney along with the land on which the Phoenix Emporium was built.

In 1866, Howard Swain, who was leasing the property from Putney, expanded his line of services by adding a blacksmith shop in the back of his small store. He continued to operate the business until around 1873, when Joshua Warfield Dorsey bought the property and began delivering coal and ice from the site. Records show that Joshua may have died in late 1880, but evidently the business remained in the family. In 1885, the

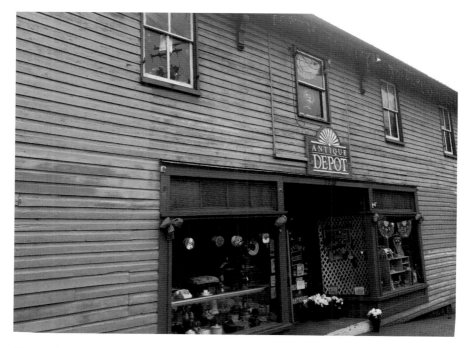

Former site of Edward T. Clark & Sons, this building is now home to antiques and unseen entities from the past. *Shelley Davies Wygant.*

Dorseys built the present frame warehouse and broadened the business to sell hardware, fertilizer and farm supplies. They also ran the Dorsey Livery Stable on the site.

In 1924, Edward Talbott Clark bought the property and the business. As part of the deal, Clark stipulated that Dorsey couldn't operate a hardware/farm supply store within twenty miles of Ellicott City for ten years. At some point early in the business's history, Edward partnered with Billy Owings and operated the store as Clark and Owings. Later, the name changed to Edward T. Clark & Sons, which was painted on the front and side of the building along with a Ralston-Purina "Purina Chows" checkerboard design. Clark and his young sons, Edward Talbott Jr. and William, operated the store, which sold everything from leather harnesses and tack for farm animals to expensive handmade nails.

Edward T. Clark & Sons remained a fixture in downtown Ellicott City through most of the twentieth century. In the 1960s, Edward Jr.'s sons Andy and Edward T. Clark III went off to become military officers. The business thrived during the years they were away, but on March 29, 1972,

the happiest times of the Clark family ended. On that night, Edward Jr. and his wife, Marie, were killed in a car accident in Anderson, South Carolina. The grief-stricken brothers decided that Andy, who was an army captain at the time, would be the one to resign his commission and come back to run the business.

Just a few short months after the elder Clark's death, tragedy struck the family yet again. According to an article in a 2016 online edition of *Hardware Retailing*, Andy recalled, "The day I out-processed was the day Agnes came through and washed out the store," referring to the devastating tropical storm that flooded lower Ellicott City on June 22, 1972. Had the storm hit before he resigned his commission, Clark said, the store would never have reopened.

As it was, the new owner of Clark's Hardware walked into a store that had suffered $70,000 worth of damage. Despite the business's long tenure in the town, local banks weren't willing to lend money to the inexperienced Clark brothers. So, they re-mortgaged the family home to get the working capital to get started.

Through sheer determination and by working eighteen-hour days, they reopened the store. The next year, in 1973, they moved the business to St. John's Plaza. The Clark family hung on to the building until 1989, when they sold it to the Antique Depot for $600,000. Ownership has since changed hands, but the old feed store building continues to feature four floors crammed with retro relics, vintage finds and antique gems that draw shoppers looking to lose themselves in an hours-long treasure hunt.

THE HAUNTING

Although the U.S. Census shows the Dorseys living at the address in 1900, the building and grounds were used as a commercial site for almost all of its 150-plus-year history. One can easily imagine that over the many decades there may have been accidental injuries or deaths on the site, although none have been documented. But death was always close by.

The property was adjacent to the buildings where Bernard Fort had his cabinet- and coffin-building shop and may have also been a place where the bodies of victims of the 1868 flood were gathered and laid out to be identified. That may explain the apparitions that many vendors and visitors at the antiques mall claim to have seen and heard over the years.

Two of the ghosts are said to be the spirits of little girls who are sometimes unseen but make their presence known with the soft sounds of childlike laughter and giggling. Occasionally they will materialize as ghostly figures in old-fashioned nightgowns on the first floor of the store. Despite their lighthearted laughter, employees and shoppers who have seen them say they are left with a distinct feeling of sorrow after seeing the girls.

Another spirit seems to haunt the dungeon-like basement of the sprawling building that has been added onto and expanded over the years. It's said that one day, an antiques vendor who descended into the cellar was so startled by the vision of a young woman dressed in Victorian-era clothes that she bolted up the stairs and never returned.

Visitors frequently report walking through unexplained pockets of cold air. Former employees say that on some mornings the building has an eerie, almost electrical feeling. But the most disturbing accounts of paranormal activity are attributed to an enigmatic entity that a former shopkeeper named "Bart."

The descriptions of this ghostly manifestation are strange and very specific. According to those who have caught a glimpse of the specter, he is an older man dressed in nineteenth-century work clothes. Sometimes, he suddenly appears standing in one of the antique stalls. At other times, he's been spotted at the end of one of the aisles, sitting in the bed of an old wooden handcart, as if he is taking a break from his work as a blacksmith or livery hand.

Those who have seen him say his hair is long enough to brush the shoulders of his faded collarless shirt that has loose-fitting sleeves and is covered by a dark vest. From what they can tell, he is wearing leather shoes that bear the scars of years of heavy labor. Some say he wears the kind of broad-brimmed, flat-topped hats that Quaker men wore in colonial times. As distinctive as his clothes are, his eyes are what witnesses most remember with dread and horror.

People who have been startled by his sudden appearance warn others not to look the specter in the eye. One person who dared to meet the old man's ghostly gaze said he was "overcome with the deepest depression he had ever experienced." He said the dark feeling of fear and apprehension was so strong that it engulfed him for more than two hours, and during that time he didn't care if he went on living. Gradually, the cloud of doom lifted, but the witness said if he ever saw the old man again he wouldn't risk looking him in the eye.

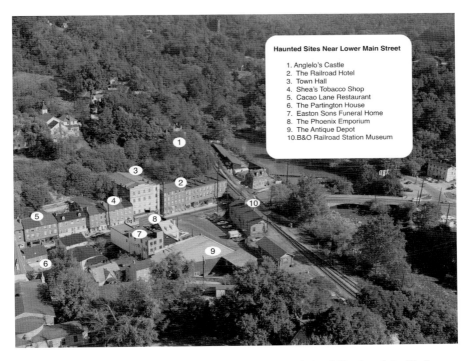

Haunted Sites Near Lower Main Street

1. Anglelo's Castle
2. The Railroad Hotel
3. Town Hall
4. Shea's Tobacco Shop
5. Cacao Lane Restaurant
6. The Partington House
7. Easton Sons Funeral Home
8. The Phoenix Emporium
9. The Antique Depot
10. B&O Railroad Station Museum

Additional haunted sites include the Patapsco Hotel to the right of No. 2 and the Trolley Stop across the river. *Library of Congress Historic American Buildings Survey.*

Others to whom "Bart" has appeared say that, although returning the gaze of the ghost sparks the most serious feelings of dread, simply being in the presence of the spirit of the old man brings on a sense of sadness, and that the cold air of gloom lingers long after he vanishes.

Whether the ghosts that wander the crowded aisles of the former farm supply store are those of the poor souls who perished in the flood or that of a disgruntled former employee who couldn't leave his grudges in the land of the living may never be known. What seems certain, however, is that visitors who come to the building looking for the perfect antique to complete their collection may find themselves face to face with a view of the past that could haunt them for the rest of their lives, and maybe beyond.

PART II

HAUNTINGS ON THE HILLS

LILBURN

SORROWFUL STONE MANSION IS
STEEPED IN UNTIMELY DEATHS AND MISFORTUNE.

As ONE OF THE MOST haunted houses on the East Coast, Lilburn is a home that is notable for both its extraordinary beauty and the sheer number of tragedies that the home and the families who lived there have endured. Alternately known as "Henry Hazelhurst's Villa," "Hazeldene," "Balderstone's Mansion [sic]" and simply the "Castle," Lilburn is located on College Avenue. Enigmatic and enchanting, this distinctive stone mansion has lured buyer after buyer into its haunting embrace, where it's said that anyone who dares to purchase the property "leaves divorced, destitute, or dead." That is, if they ever leave at all.

THE HISTORY

Lilburn stands on what was originally a 361-acre land grant called the "Valley of Owen." Patented to Captain Richard Owings, the "Settler," on May 20, 1705, the grant was likely named after Cwm Owain, or "Valley of Owen," near Llanllugan in North Wales, where Owings was born.

On September 23, 1748, Richard Owings II passed the Valley of Owen to his son Richard Owings III. Records show that Owings later sold it to Caleb Dorsey Jr., who lived at the nearby Belmont. Dorsey died in 1772, and the land may or may not have remained in the family until the mid-1800s,

when John C.D. Thomas is listed as owning the part of the Valley of Owen where Lilburn would eventually be built by Henry Richard Hazelhurst.

Born in England in 1815, Hazelhurst was actually baptized Richard Henry but changed his name to Henry Richard when he was still a young boy because he liked the name better. In 1819, he returned to America with his Philadelphia-born father and the rest of his family. They lived in Salem, New Jersey, until 1831. After his father's death, he went to work for the Baltimore & Ohio Railroad.

A short time later, Hazelhurst formed a partnership with Thomas C. Atkinson, a fellow engineer at the B&O Railroad, and started a firm in Cumberland. Despite living in Cumberland, his ties to the Ellicott City area were strong. On what were probably many trips back east, he met and courted Ellen Thomas, the daughter of Dr. Allen Thomas and Eliza Bradford Dall of "Dalton." The couple married on June 24, 1844.

The newlyweds settled into their home in Cumberland, and it was there that the first of many tragedies struck. A little less than four years after they were married, Ellen became pregnant with their first child. She went into labor and delivered a daughter on January 24, 1848. There must have been complications; just six days later, Ellen passed away on January 30 at the age of thirty.

Heartbroken at the loss of his young wife, Hazelhurst named his newborn daughter Ellen in her memory. Whether because of grief or for business reasons, he left Cumberland and moved back to Baltimore around 1850. There he began keeping company with Elizabeth Virginia McKim, daughter of David Telfair and Sarah Beatty McKim.

Known as "Lizzie," she was just twenty-six when she and thirty-eight-year-old Hazelhurst wed on October 4, either in 1852 or 1853. On August 24, 1854, Lizzie and Henry were thrilled to welcome their daughter Maria Eleanor into the world at their home in Baltimore. A little more than a year later, on November 28, 1855, their son Charles Blagden was born.

Now forty years old, the prosperous industrialist looked toward retirement and the countryside just outside of Ellicott City. He started inquiring about property that his former in-laws, the Thomas family, owned. Although Henry was the widowed son-in-law of the Thomases, records show that the "Valley of Owen" property came to Hazelhurst through his second wife, Elizabeth McKim, who acquired it from three deeds. The one dated October 14, 1857, from William B. Thomas mentions "a new house now being built by Henry R. Hazelhurst." His massive stone villa would be built on that parcel of less than five acres.

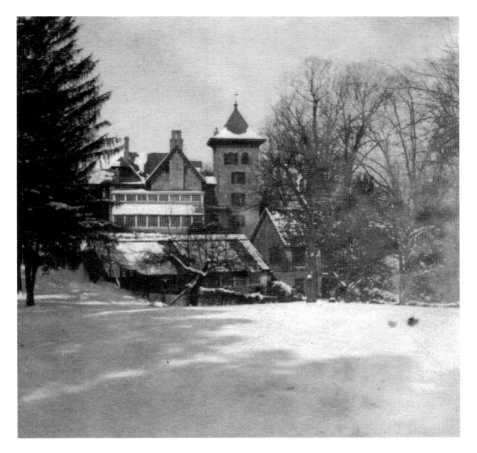

Before it burned in 1923, Lilburn's tower was topped by a Gothic spire and sported a glassed-in conservatory on its south side. *Weld-Keller Family.*

Located just a little up the hill from Rock Hill College, the site once had commanding views of the town. Hazelhurst named his new home "Lilburn," an English medieval locational surname that means "the stream where the lillies grow." It may have been a nod to both his homeland and the small creek that flows behind the mansion.

"Henry Hazelhurst's Villa" was then, as it is now, one of the most magnificent homes in Howard County. Constructed of massive ashlar granite blocks that were probably quarried behind the home along the Patapsco River, the twenty-room Gothic Revival mansion is an architectural marvel. The cruciform floor plan features a four-story Romanesque tower originally topped by a Gothic-spire roof as well as a one-story bell tower.

When it was first built, the home had matching stone-floor-covered piazzas on the north.

Not long after the Hazelhurst family moved into their stately stone villa, Lizzie gave birth to their second daughter, Catherine Lilburne, on December 1, 1857. Unfortunately, the joy of moving into their new home and the birth of their daughter wouldn't last. The angel of death visited the Hazelhursts yet again.

Whether it was because of sickness or an accident, their four-year-old daughter, Maria Eleanor, passed away on February 26, 1858. Records show the place of her death as Baltimore, which may mean she was taken to be treated by a doctor in the city. The grief-stricken parents brought the body of their child back to Ellicott City and buried her in the cemetery at St. John's Episcopal Church, where Hazelhurst served as a vestryman.

In subsequent years, the Hazelhursts had three more daughters: Margaret McKim, born on June 9, 1859; Julia Latrobe, born on November 18, 1861; and Elizabeth McKim, born in May 1865.

Although it's said that Hazelhurst was a Southern sympathizer during the Civil War and that his leanings hurt his business interests, his land purchases and expanding household during that time and afterward indicate that the family continued to prosper. The 1870 U.S. Census lists the Hazelhurst family, along with a governess, seamstress, dairy maid, coachman, waiter, laundress, cook, maid and cow driver, living at Lilburn or in dependent buildings on the property.

The next decade began with sorrow when the cold hand of death reached into the mansion to take Hazelhurst's wife, Lizzie. Latrobe family records say she died on July 31, 1887, but her gravestone reads "1881." If the gravestone date is correct, she didn't live to see any of her daughters' weddings.

Elizabeth was the first to marry. The ceremony was conducted at Lilburn on November 1, 1882. Two years later, in October 1884, Margaret got married, followed by Julia in April 1891. Sadly, that wedding marked the end of that brief period of happiness at Lilburn.

Shortly after the wedding, death came knocking at the door once again, on June 30, 1891, when it carried away Hazelhurst's thirty-four-year old daughter Catherine. It returned on September 15, 1893, to snatch thirty-two-year-old Julia, who may have died in childbirth. Both sisters died at Lilburn. On July 7, 1895, Margaret followed her sisters to the grave at her home in Chestnut Hill, Pennsylvania. Only Hazelhurst's son George and his two married daughters, Elizabeth Gordon and Ellen Healy, remained.

With the house now emptied of all his loved ones, Hazelhurst spent the next five years reflecting on his life's many tragic losses. He'd lived long enough to see the deaths of both of his wives as well as four of his seven children. During the last few years of his life, he began selling off the land around the mansion. Finally, on February 21, 1900, Henry Richard Hazelhurst departed this life in his magnificent stone villa and joined his wives and children in the family plot at St. John's Cemetery.

Evidently, Hazelhurst's remaining children didn't want Lilburn or couldn't afford to keep it up, so later that year, on November 19, the mansion, along with fifty or so acres of land, was sold to the Independent Order of Odd Fellows of Maryland for $17,500. The organization had planned to turn the home into a meeting place for its members. However, just a few years later, it sold the mansion along with its original stone icehouse and carriage house, as well as Lilburn Stables and various tenant cottages, to Robert H. Weld on September 10, 1906.

Like Hazelhurst, Weld was an Englishman. Although the land records refer to him as Robert, his name is listed as Albert Henry in the U.S. Censuses of 1910 and 1920. He and his wife, Nannie Bruce Howard, along with their two daughters, Edith Mary and Mary Katherine, stepdaughter Josephine E. Browne and numerous servants settled in to enjoy a life of luxury in the majestic mansion they renamed "Hazeldene."

Unfortunately, their happiness soon came to an end when the grim reaper once again came calling at the mansion. Just a few years after they moved in, Nannie was diagnosed with a brain tumor. She died on June 2, 1911, at the age of forty-four. Weld and his teenaged daughters remained at Hazeldene until his death in May 1922.

After Weld's death, the girls were sent off to live in Europe. On June 9, 1923, the mansion, along with its fifty acres of land, was sold to insurance executive John C. Maginnis and his wife, Mary, for $20,000.

The Maginnis family had barely settled in when yet another disaster roared through Lilburn. Just six months after they purchased the property, the Christmas tree in the bay window of the front parlor caught fire. The blaze rapidly spread through the house, destroying the Gothic-spired roof of the tower as well as much of the interior of the house, leaving "only the beautiful spiraling stairway hanging grotesquely in mid-air."

Undaunted, Maginnis restored much of the interior of the home to its original glory, with the exception of the staircase and the tower roof. Instead of ascending all the way to the third floor, the stairway now stops at the second floor; the third-floor landing was turned into a balcony.

Maginnis replaced the Gothic spire roof on the tower with a crenelated parapet that gave the home the look of a medieval castle. Today, almost a century later, one can still see the physical evidence of the fire on the charred beams in the attic, two stories above the front parlor where the burning Christmas tree stood.

Whether because of death or financial troubles, the Maginnis family lived there only a short while, because on July 18, 1930, Joshua N. and Jacob S. Warfield were appointed as trustees to sell the property. Just a year or so after the stock market crash, the trustees sold Lilburn and twenty acres of land to Beth Hillel Sanitarium for $16,500. The facility had planned to make it a home for developmentally delayed children. That plan went by the wayside; the sanitarium almost immediately sold it to Henry Knott later in 1930. Knott sold the property to Alfred Victor Weaver in 1934.

At the time, Weaver was employed as treasurer at Eureaka Maryland Assurance Corporation in Baltimore. It's said that while he didn't do much to Lilburn's interior, his wife, Gertrude, who evidently was quite the gardener, "achieved great success in her attempt to restore picturesque beauty to the gardens of the castle on the hill." During their time at Lilburn, the Weavers turned Lilburn Stables and tenant homes on the south side of the property into low-cost housing and built other cottages on a lane that would be called Weaver's Court.

After Gertrude Weaver's death, Lilburn passed to her daughters Ella Gassaway and Katherine Sullivan in 1949. It's said that the property went to Ella and her husband, Dr. William Gassaway, after Katherine died. Apparently, the doctor and his wife didn't want to live at Lilburn, so they chopped up what was once a grand mansion into rental apartments.

Lilburn would have to wait more than fifteen years to return to its former glory when Sherwood and Anne Balderson purchased it in 1965. They quickly set about removing the temporary apartment walls and restoring the home to the elegant single-family home Hazelhurst had envisioned. They and their five children lived there until 1974, when they sold the property to Drs. Eugenia Zacharias Marchese and her husband, Walter Bradley King Jr.

Within a few years, the Kings divorced, and Walter signed over the house to his former wife in 1977. Eugenia stayed on at Lilburn with her son Walter Jr. until 1983, when she sold the house to John W. and Julie H. Whitney. The Whitneys lived there until 1987, when they sold the property to Dr. Randall Gatlin Brandon and his wife, Anita Ilene Brandon, for $585,000.

The Brandons also fell victim to the curse of Lilburn; they, too, split up. In 1995, John Whitney sold the home to advertising executive Chris Cotter

and his wife, Janet, for $625,000. Two years later, Historic Ellicott City Inc. redecorated and renovated the home as part of its 1997 Decorator Show House fundraiser. During their time at Lilburn, the Cotters subdivided and sold off the tenant cottage next to the mansion.

In 2004, Debra McGinty and her husband, Thomas, purchased the home along with the remaining seven acres for $1.2 million, hoping to turn it into a bed-and-breakfast. Unfortunately, the couple divorced, and the inn never opened.

The next owners were Geoff and Patricia Driscoll Hermanstorfer, who bought Lilburn in 2007 for nearly $1.4 million and lived there with their son Houston. Like so many before them, they, too divorced. Driscoll, a defense company CEO and former executive director of the Armed Services Foundation, kept ownership. As of this printing, she lives there with her new husband, John Eric Morris, and whatever ghosts remain at the mansion

THE HAUNTING

No one knows whether the ghosts of his wives and departed daughters kept Henry Hazelhurst company during the last few years of his life at Lilburn. Descendants of the Weld family who moved in afterward don't recall any tales being told of specters roaming the mansion. What we do know is that something changed after the fire of 1923. The raging inferno that consumed much of the home's interior seems to have awakened the previously slumbering spirits.

After the Maginnises' renovations were complete, the strange happenings began. The family often heard the heavy sound of pacing footsteps in the highest level of the tower, as if someone was agitated or perhaps angered by the changes made to the home. The son of a later resident, John Balderson, said he heard the footsteps above his third-floor room in the tower "on almost a nightly basis" for five years straight but learned to live with it.

Footsteps weren't the only odd occurrence in the tower. Despite being carefully and very deliberately locked, and on one occasion tied down with ropes, the windows in the room under the new parapet roof would frequently be found open shortly after they were secured.

If the pacing ghost with a preference for open windows is indeed Hazelhurst, he doesn't confine himself to the tower. A housekeeper for the Baldersons claimed to have smelled a man's cigar in the library, where Albert

Weld is said to have died. She also reported hearing a child crying, as well as seeing several apparitions, including the shadowy figure of a man and a girl in a chiffon dress, walking down one of the hallways.

All told, nearly ten people either died at Lilburn itself or during the time that they owned it. Consequently, there has been a lot of speculation over the years about who might be responsible for the many other supernatural happenings at this house of many sorrows.

One, reported by the Baldersons, occurred in the back hallway outside of what once was four-year-old Maria's nursery. One day, they found the family dog, a seventy-pound Weimaraner, in what they described as "a frenzied panic." He was on full point, his fur standing on end and snarling at an unseen presence. After taking the dog outside, he continued to shake and became violently ill. Afterward, he refused to go back into that hallway.

Was it the presence of Maria, who died shortly after the Hazelhursts moved in, or her mother, Lizzie, who came back to mourn the child that was taken from her at such a tender age?

Balderson family members and servants weren't the only ones to witness unexplained happenings. One evening in the grand dining room, dinner guests stopped their conversation and raised their eyes to the ceiling in response to a muffled sound overhead. As they looked up, the massive crystal chandelier inexplicably began swaying back and forth and then abruptly stopped. Before the stunned guests could comment, the light fixture started swinging a second time. It stopped again and then started swaying a third time. Whether caused by a presence in the bedroom above them or a spirit swirling through the dining room, the chandelier came to rest for the remainder of the evening, leaving the wide-eyed dinner guests speculating about who or what had caused the disturbance.

For reasons of their own, the Balderson family seemed to resign themselves to living in relative peace with the spirits. Anne Balderson was quoted as saying, "We do not want to drive out or exorcise the presence at Lilburn. We feel that whatever it is, is a tortured spirit—certainly not an evil one." She added, "I am not a mystic, yet I know and believe that the 'thing' at Lilburn has more of a right to be here, than I."

Lilburn's next residents, Dr. Eugenia King and her son Walter, also had experiences with the supernatural "thing" that inhabited the house. The tower windows continued to refuse to remain locked, and the family was also treated to the disturbing spectacle of the swinging chandelier. In addition to the earlier reported manifestations, the Kings also witnessed a vase filled with flowers from the garden suddenly turned upside down by unseen hands

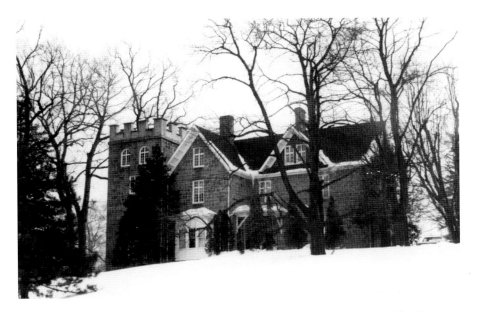

Lilburn post fire. The window on the second floor under the far-left gable is said to be Margaret's room. *Celia Holland Papers, Special Collections University of Maryland Libraries.*

and emptied onto the floor. On one occasion, a guest was pushed into the mansion's pool in the only reported instance in which the spirits physically interacted with the living.

The most recent evidence that Hazelhurst and his family members might roam the halls of the castle came in 1997. It was the night of the Historic Ellicott City Inc. Decorator Show House Preview Party. Guests who were sipping wine in the garden and exploring the mansion were suddenly plunged into total darkness. Every light in the twenty-plus-room home were extinguished in an instant. More than a few screams of fright went up among the guests. Before panic could fully set in, the lights came back on as suddenly as they had gone out. With no earthly explanation for the blackout, many in attendance speculated that Hazelhurst, whether in protest or approval of the redecoration of the house, was signaling his presence to the living nearly one hundred years after his death.

TONGE ROW

RESTLESS ENTITY WATCHES OVER THE INVESTMENT OF TWO ENTREPRENEURIAL ELLICOTT CITY WOMEN.

AMONG THE MOST PHOTOGRAPHED, SKETCHED and painted scenes in Ellicott City, this picturesque collection of three semi-detached double stone cottages and a frame structure is clustered along a curve on Old Columbia Pike. Although they were originally constructed as rental homes for mill workers, the buildings now house charming retail shops, offices and restaurants that are filled with delights for visitors during the day—and more than a few frights for those who dare to stay after the sun goes down.

THE HISTORY

The birth of Tonge Row took place on May 23, 1839, with the death of sixty-five-year-old James Tonge. Born in England in 1774, he and his wife, Ann, came to America in 1833 and settled in Baltimore, where they raised two daughters.

After James's death, his forty-seven-year old widow purchased a "tract of land on Columbia Pike" from John Day, who lived just down the street. She began building a row of duplex stone cottages on Columbia Pike, completing one each year.

When she was finished, there were six individual dwellings in her newly constructed three-duplex row. Each duplex had a central chimney and featured two stories with a door facing the road and a walk-out bottom floor

with a door in the back. On February 26, 1844, Ann paid off the property and soon after began renting the tidy cottages to Ellicott City mill workers and their families.

With her financial future secure, Ann settled into life as a woman of independent means in her adopted town. The 1860 U.S. Census shows her living alone next to James Gowan's Railroad Hotel on lower Main Street. At the time, she owned a total of $6,000 of real estate and $100 in personal property.

She died three years later, at the age of sixty-nine, leaving a substantial amount of real estate to her daughter Margaret Hughes and granddaughter Sarah Ann Fusting. Her will, dated February 3, 1863, left the northern half of Tonge Row to Sarah; Margaret inherited the southern half.

Little is known about Tonge Row during the decades immediately after Ann's daughter and granddaughter inherited the properties. They may have continued to be rented out to mill workers and were likely bought and sold many times over in the next one hundred years.

In 1962, one of Maryland's most highly celebrated photographers, A. Aubrey Bodine, was assigned by his employer, the *Baltimore Sun*, to photograph Ellicott City. His outstanding shot of Tonge Row was so

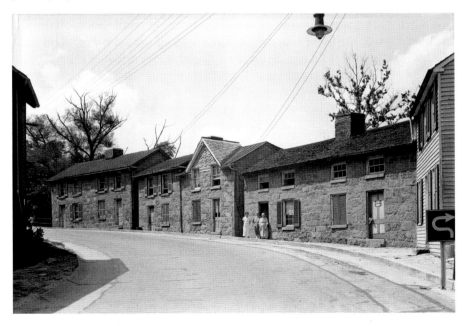

The three double stone homes along Tonge Row face the former Taylor's Row Livery Stables. *Library of Congress Historic American Buildings Survey.*

beautiful that the National Trust for Historic Preservation included it in its 1962–63 traveling display.

A few years later, in 1967, a local woman by the name of Esther Rettger began purchasing the houses. In an article in the *Baltimore Evening Sun* dated April 23, 1979, she recalled: "I used to drive by and I always liked them, but I was not in the real estate business. Then one day I saw a for-sale sign. I called up and bought [the first three] for $2,000. I paid $3,000 for the other two a couple years later."

She laughingly went on to say, "By the time I bought them there were at least 20 cats living in one of them. They were all a mess. A big heap of nothing."

Fixing them up was a major project. Rettger had to put all new beams in one. The mortar between the granite blocks had disintegrated in another of the buildings, opening holes big enough to let birds fly in and nest in the walls. During the time that Rettger owned the properties, she rented retail space to a variety of merchants, including an herbalist, a florist, an artists' co-op and a dog groomer.

Later retail tenants in the frame building at 3732 Old Columbia Pike included the Wexford House Shop, as well as the current Hi Ho Silver Co. Over the years, shops in the stone houses have included a "head shop" called the Front Room, Pieter Meerschaert's Shop, R&R Unlimited Antiques (Clays Fishing & Hunting), Drugsensic Counseling and Mental Health, Hysterical Tattoo, Patapsco Motor Sports, the Rebel Trading Post & the Arms Room, the Gray Hare, the Waning Moon, the Little French Market, La Boutique de Mon Ami, ScoopAHHHDeeDoo, Natural Bath Works, the Good Life Market, River House Pizza, Ghost Lounge Hookah Bar, A Journey from Junk and many others.

Tourists and retailers aren't the only people who love the old-world charm of these distinctive stone buildings. Filmmakers have reportedly used the row houses as a location for movies and television productions. Whatever it is, there's something about Tonge Row that draws people to live and work there. Sometimes, it never lets them go.

THE HAUNTING

Stone buildings seem to be especially prone to retaining the psychic energy, angst or longings of the hundreds of people who have walked in and out of their doors.

One seems to be the persistent spirit of a young girl who is known as Cecilia. Although often seen wandering through the rooms at night by apartment residents, she seems to take particular delight in scaring shop owners.

During the time when a hair studio occupied one of the buildings, stylists would arrive for work on the coldest days of winter and find all the air conditioners running and turned on high. Occasionally, one of them would feel the chilly pressure of an invisible hand on her shoulder, only to turn around and find nothing there. Others said they heard whispered words and phantom footsteps and felt unexplained tugs on their clothing as if someone—or something—was trying to get their attention.

Occasionally, the phenomena have been more physical. A shop owner reported coming in one morning and finding items on a display table inexplicably flipped over. Another owner, who apparently disturbed the spirits, had a deck of cards flung at her. A painter had a stuffed animal appear and hit him out of nowhere.

One of the strangest tales involves what was thought to be a break-in at one of the stores. It seems that when the shopkeeper came to open the store in the morning, she was surprised to find a broken window and the door slightly open. Fearing the worst, she pushed the door open to look around. At first glance, it seemed like nothing was missing. Relief was quickly replaced

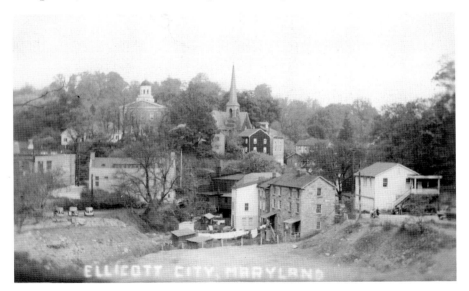

Early 1940s view of the back of Tonge Row. The "new" post office building is visible directly below the courthouse. *Howard County Historical Society.*

by shock and a deep sense of unease when she looked down to find a perfect semicircle of dolls and stuffed animals just inside the door—something that would have been impossible for someone leaving the shop to do.

Could it have been Cecilia who put up the barrier and scared the window breaker away? Or is it the ghost of Ann Tonge who stayed behind to look after her investment? What does this female entity want? Two employees at the former hair salon might have had the chance to ask her one day when they heard light footsteps coming up the stairs as they went about cutting and styling their clients' hair.

Thinking it was the owner, they weren't concerned and continued to snip away in front of their mirrors until a bit of motion caught their eye. They froze in horror as they watched the misty shape of a woman float up from the stairwell behind them and then dissolve before their eyes before they could turn around to look or ask why she was there.

Whether her actions reflect annoyance or a deep desire to simply be acknowledged may never be known. But what is certain is the belief that somebody not of this world lives on in the shops on Tonge Row.

TAYLOR'S ROW LIVERY STABLES

MYSTERIOUS "LADY IN WHITE" HAUNTS THIS STABLE TURNED TAVERN.

HAUNTINGS HAPPEN EVERYWHERE. PLACES WHERE people lived, worked or just passed through can be spots to which a spirit becomes attached. However, places where people have died or, worse yet, been murdered, seem particularly prone to becoming a haven for souls that have been violently separated from the mortal world. This seems to be the case for the former livery stables known as Taylor's Row.

THE HISTORY

Built sometime between 1830 and 1870, this haphazard series of wood-sided buildings located at 3733 Old Columbia Pike originally housed stables that served the livery trade of the area. Empty and abandoned for decades, Taylor's Row was renovated in the late 1990s and turned into a restaurant called the Mill Town Tavern, which was replaced by the Tiber River Tavern and then by the Diamondback Tavern. In 2017, the roadside pub was sold yet again and extensively renovated to become the home of the Manor Hill Tavern.

Inside the hodgepodge of buildings where early visitors to Ellicott City might have stabled their horses while they strolled around the town is a series of stepped rooms with exposed stone walls that serve as the restaurant and kitchens on the first floor. The upstairs, where bales of hay were likely stored,

now features two large dining rooms. Other second-story rooms farther up the hill are used as office space. According to past visitors and tavern employees alike, the premises are crawling with ghosts and otherworldly beings that occasionally make their presence known.

THE HAUNTING

Legend has it that sometime in the 1920s, a woman was attacked and killed at the stable and that her spirit lingers and appears as a ghost known as the "Lady in White." A bartender during the Diamond Back Tavern era recalled seeing her more than three times. The floor plan has since changed, but during the earlier incarnations of the tavern, there used to be a long bar along the back wall of the large room to the right of the entrance. There were double doors to the kitchen at the far-right end of the space.

The first time the bartender saw her was when the restaurant first opened. He said he caught a glimpse of her through the windows of the double door. She was standing at the end of the bar. The restaurant hadn't opened yet, and he was concerned that someone had gotten in, so he pushed through the doors and started toward her. When he did, she turned to her left and walked toward the back hall that leads to the bathrooms. As he came around the corner, she vanished.

The second time, he only saw the white outline of her petticoats, but he knew it was her. He followed her again toward the bathrooms; as he came around the corner, again she was gone. The third time, she appeared in the lower-level main dining room and seemed to be headed toward the bar area.

Employees during the Tiber River Tavern era reported opening the restaurant and seeing bare footprints on the newly varnished floors. They told of hearing strange noises, distant voices and muffled footsteps as well as experiencing sightings of the Lady in White. On one occasion around closing time, the employees heard a loud, unexplainable crash above them. The owner ran upstairs, unlocked the room and found a table completely overturned.

But that wasn't the strangest part.

Instead of the place settings being scattered across the floor as one might expect, they remained perfectly in place, beneath the overturned table. Other ghostly manifestations have included the appearance of a transparent female face "that wasn't human" in the window, witnessed by a county police officer.

Another longtime bartender at the Diamondback who had also worked at the Tiber River Tavern felt uncomfortable talking about what he'd experienced. He said, "I hate the ghost and every time I talk about her something happens and, plus, I don't believe in it."

Eventually, he relented, saying, "Ok, I will give you one of my stories, but just one and maybe the best one.

"It was a busy day," he began. "I was a barback then. I helped the bartenders clean up. It was the end of our shift, and the bartenders were all gone for the night. At that time, the tables in the lower-level dining room had white tablecloths and candles in the middle. During dinner service, we would light the candles and at the end of the night all had to be blown out before closing. Since I was the only one left downstairs I blew out all the candles."

He went on to relate:

> *The general manager who was also a head bartender was upstairs, so I headed up to speak with him and let him know everyone was gone. He then came downstairs to check on things and started yelling for me to come back down and seemed upset. He said, "What the heck! I thought you said you had closed up!"*
>
> *"I did," I responded, and he said, "Well you better look again." So as I went into the dining room, all the tablecloths were lifted up in a bundle on the tables and I mean all the tables and one candle in the back was still lit. I was scared and just stared at the mess. The GM asked me again what had happened, I could not even answer, and I ran through the kitchen and out of this place.*

The doors of this haunted tavern remain open, welcoming pubgoers with a hearty meal, a frosty pint and the possibility of peering into the world beyond this one.

JOHN DAY HOUSE

SALON VISITORS REPORT "TOUCHING" EXPERIENCES AT A HOUSE OF MANY MYSTERIES.

THE FIRST MYSTERY OF THIS charming house located at 3723 Old Columbia Pike is why it is built of brick when the first owner was a master stonemason. The second is the nearly forgotten graveyard at the rear of the home. And the third is the identity of the ghosts that remain in the house that became a beauty salon.

THE HISTORY

In 1830, George Ellicott, Samuel Ellicott, Andrew Ellicott and John Ellicott divided up the land that had been settled by the original Ellicott brothers. The Day-O'Neal-French House is located on Lot 11 of that partition of the Ellicott's land, located just down the hill from the Quaker Meeting House and Cemetery.

John Day purchased the lot in 1842 for the low price of $250, which suggests that there was not a house or other buildings on the property. The 1850 U.S. Federal Census shows thirty-five-year-old John living there with his twenty-nine-year-old wife, Sara, and five-year-old son, Thomas. In spite of the fact that John was listed in the census as a master stonemason, the house was constructed of brick, which may have been seen as a more upscale material.

The source of the spirits at the John Day House may be a nineteenth-century private burying ground located on the hill behind the home. *Shelley Davies Wygant.*

The home itself was modest, with two small rooms on the first floor and two rooms of the same size above, plus a built-on kitchen. Two fireplaces warmed the household, which, by 1860, included a young African American girl, Mary Hopkins, age eleven, who was listed as a "house servant."

In 1904, the O'Neals sold the home to John and Mary French, who had been living on Main Street. They lived there with their children Mary and John. Later, the home was sold to Mr. and Mrs. John T. Ray.

Aside from owning the home, the Rays have the sad distinction of burying their infant son in the .62-acre Day Cemetery at the rear of the house, which was laid out in 1844. As of the 1970s, there were still some identifiable graves remaining, but the markers have disappeared.

Other owners have included Mr. and Mrs. Carl Schwartz, who made many improvements, including removing the wall between the two first floor rooms to make one open, spacious living room.

In 1957, Mr. and Mrs. Adolph B. Puhl purchased the home. Unfortunately, Adolph died suddenly, exactly one year to the day after they moved in. Mrs. Puhl and her son Edward continued the renovation, including restoring the original winding closed stairway.

In the 1970s and 1980s, the home became a teahouse and café. From 1993 to 1999, the John Day House once again became a private residence, owned by Dodie Stewart. In 1999, David and Connie Ennis purchased the home and transformed it into an upscale beauty salon. Their daughter now runs the business, and this is where the ghost stories begin.

The Haunting

According to the Ennis's daughter Leeza, the John Day House is haunted by two entities. One is a "ghost masseuse." Some call her Susan; others refer to her as Catherine. The staff reports that she is a mostly friendly, almost motherly presence that has never materialized but is only sensed. Customers, too, say they have felt the presence of the ghost. Some claimed to have been touched. Others have heard frequent footsteps above them when they are on the first floor. The daughter said that, on one occasion, she felt pressure on her back when she was on the first floor of the building as if someone was poking her with their finger. When she spun around to see who was trying to catch her attention, no one was there.

On the first day of work, a newly hired shampoo tech who was sensitive to the supernatural felt uneasy and wanted to know if someone had died upstairs. The ghost seems to want the salon's earthly inhabitants to know she is there. One time, when Leeza's then fiancé was peacefully napping upstairs on a massage table, he woke with a start as he felt himself pushed off the bed by unseen hands. Needless to say, now he keeps his eyes wide open whenever he's at the salon and won't go upstairs anymore.

Less ominous is the other ghost, a phantom cat that they've named Casper who appears as a furry blur that shoots across the room and disappears into the wall.

Whether Susan is indeed a "ghost masseuse" or one of the restless inhabitants of the backyard cemetery may forever remain an unsolved mystery of the John Day House.

AL'S GARAGE

SPIRITS SWIRL AROUND AN OLD AUTO SHOP ON THE BANKS OF CAT ROCK RUN.

WHEN MOST PEOPLE THINK OF haunted sites, they picture a creepy Victorian mansion brooding behind wrought-iron gates. But sometimes that's far from the case. Sometimes the most haunted places in a community are so nondescript that they don't even merit a mention in the town's walking tour book. The old auto garage set back from the road at 3711 Old Columbia Pike certainly qualifies as one of these hidden haunts.

THE HISTORY

Likely built after the 1920s, when cars became more common, the single-story cinder-block garage is listed on the Maryland Inventory of Historic Properties as the Ridgely Building. It's located just over the hill from the Ellicott Family Cemetery on the banks of the Tiber River tributary known as Cat Rock Run or Wildcat Branch.

Some say the building is erected on the site of an early cemetery that was moved. An elderly Ellicott City resident who was a young boy when the Battle of Monocacy was fought in July 1864 claimed to have witnessed bodies of Union soldiers who died in the conflict being temporarily buried there until relatives could come and get them. Those who were never claimed may still be buried beneath the building.

Locally known as Al's Garage, the actual business name was Al's Body Shop. It was owned and operated by Albert Franklin Baer, who was born on April 4, 1960, and died of a heart attack at his garage on April 12, 2001.

Shortly after Al passed away, the grimy auto shop was transformed by Mark Mentzer and Chester Overlock into a funky home interior store called What's In Store. They filled the shop with everything from sleek modern furniture to surreal overhead displays that included a Buddha and a bed float suspended high above the sales floor.

When the store relocated, the building was used for storage by a local florist. Later, a health and wellness center called the Well moved in. Run by Lance Isakov, the center offered yoga and dance classes, as well as a place for "expanding your mind, body & spirit." The garage got its most recent makeover by Sheela Lal. As of this writing, it is home to her namesake, Ooh La La! Hair Salon.

From its eerie origins as a possible burying ground to its recent retail reincarnations, this out-of-the-way former auto shop also has a long history of alternately frightening and amusing paranormal occurrence.

Now a hair salon, this squat cement-block building was home to Al's Body Shop, where the owner died of a heart attack. *Shelley Davies Wygant.*

THE HAUNTING

Although Al Baer is no longer here to tell his story, friends and relatives say that while he was alive he frequently saw "people" flitting in and out of the shadows in his garage. While we may never know whether or not he experienced otherworldly visits from the spirits of slain soldiers buried beneath his shop, his ghost may have stuck around to make a few of his own.

The stories began with the opening of What's in Store. One of the new owners, Chester Overlock, reported that when the shop began doing business, one morning out of the corner of his eye, he spotted a man leaning against the wall. It was early, and thinking someone might have broken in, Overlock called out, "Hey, how did you get in here?"

The man promptly vanished into thin air. Now, Chester was somewhat of a sensitive who said he regularly "saw dead people," but for some reason this sighting shook him up.

When he told his business partner about what had happened, Mentzer asked what the man looked like. When Chester described him, Mentzer said, "That sounds a lot like the previous tenant, Al. The area where you described seeing his ghost was where his desk was when it was an automotive center."

Al's initial ghostly appearance was the first of many at the shop. Chester's general rule for interacting with those who have passed was to acknowledge but not encourage them. He said, "Al's friendly. I think he simply shows up for work each day to make sure everything is running smoothly."

When What's In Store moved out, Al evidently stayed. According to the owner of the Well yoga center, whatever entity inhabits the garage moved objects around, shattered a glass table, pushed over a shelving unit and tickled yoga students' feet during classes. Before the Well closed, the spiritual practitioners performed some kind of cleansing ritual to drive Al away.

Apparently, it didn't work. The manager of Ooh La La! Hair Salon says that since they've moved in, she's heard tinny 1950s music near the shampooing station, spotted a shadowy figure in overalls and felt an icy invisible hand flip up her skirt on her way out the door.

Hidden in the underbrush and forgotten for many decades, Al's Garage—and former owner Al Baer—have come out of the shadows of the past and the world beyond to make a connection with the life of the town and its people today.

OAK LAWN

ODD OCCURRENCES ARE STIRRED UP BY THE TOWN'S INFAMOUS "COOKING GHOST."

TOURISTS STROLLING UP PARK AVENUE on Ellicott City's highest hill often shake their heads with puzzlement when they come upon this beautiful mid-nineteenth-century stone townhouse known as Oak Lawn and Hayden House that is embedded into the side of the Howard County Circuit Court House. But as strange as the building's location is, longtime residents and county employees know that the unsettling manifestations inside the walls of this former girls' school are even stranger.

THE HISTORY

In 1840, forty-year-old Deborah Disney purchased ten acres of land that fronted on Frederick Turnpike. An enterprising woman, Disney knew that the Howard District commissioners were considering part of the land for the site of the new county courthouse.

She was right. In 1841, they purchased the top of the hill known as Mount Misery and began construction. In 1842, Disney sold a lot next door to Edwin Parsons Hayden for $400.

Born in 1811 in Baltimore, Hayden was a man of substance. He earned a law degree from Yale University and moved to Ellicott City likely because it had just become the county seat of the newly created Howard County and there were plenty of jobs for lawyers. Ambitious and reportedly well

spoken, Hayden took one of those jobs and, depending on which historian is cited, served as either its first or second clerk, as well as a state delegate for Howard County.

After purchasing the property, Hayden almost immediately built a handsome stone townhouse; the 1842 Howard County tax record shows he was assessed $1,600 for a "house on court house hill." The house Hayden named Oak Lawn was built as a side-passage, double-pile plan with a raised basement that probably housed a kitchen as well as storage.

When Hayden moved into the home with his wife, Elizabeth, they brought the first five of their seven children, Lewis Sydenham, Charles Leslie, Horace Edwin, Handel Mozart and Marie Victorie Evans. Space must have been a little tight, because in 1846, Hayden was assessed $300 for an "addition to dwelling." The new structure was probably an ell at the rear of the house. The Haydens likely needed the extra room for their daughter Kate Hull and son William Mozart, who were born within the next few years after they moved in.

But even with the addition, it seems the townhouse wasn't big enough. In the late 1840s, Hayden built an impressive new Italianate-style home they called Pleasant Fields just outside of town. Unfortunately, the happy years they hoped for in their new home never materialized. Tragedy struck in 1850, when Hayden died of "heart problems" at his recently constructed home before the family could fully settle in.

With Edwin gone, both Oak Lawn and Pleasant Fields were offered for sale or rent that year. Oak Lawn was described in the sales materials as "a new two-story stone building, thoroughly completed from basement to garret, and built in the most approved manner: the rooms are large and convenient: the back building contains a kitchen and breakfast room," and the home had a commanding view.

Dr. James Rowland bought Pleasant Fields, but for whatever reason, Oak Lawn didn't sell. Elizabeth moved back into her old home next to the courthouse. For the next two decades, she and two of her adult children ran a boarding school there known as the Oak Lawn Seminary for Girls.

In 1871, Elizabeth sold Oak Lawn to attorney Henry E. Wooten for $4,500. In 1890, Wooten bequeathed it to his widow, Ada, who lived there until 1915, when she sold it to Arthur Pue. It's thought that sometime during that period the ornate cast-iron porch featuring an elaborate grapevine design and posts with foliate scroll brackets was added to the front of the house.

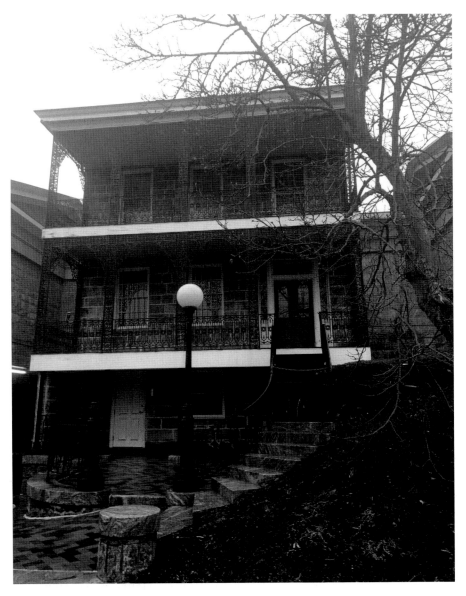

The first floor of the three-story Hayden House, or Oak Lawn, is likely where the "Cooking Ghost" serves up her spectral breakfasts. *Shelley Davies Wygant*.

Howard County purchased the home in 1937, probably as part of the expansion of the courthouse. It's thought that it was around this time that a large, one-story addition was put on the northeast end of both the main block and the ell. Later, the board of education, district court and county office of parole and probation used the house for offices. In 1981, the courthouse was expanded again, with the original plans calling for Oak Lawn to be demolished.

Fortunately, that part of the plan was rejected by the historic district commission. Although the main house was saved, the one-story addition was torn down and the interior heavily modernized. Now home to the offices of the Howard County Circuit Court, Oak Lawn still stands at the crown of Mount Misery, oddly entombed on three sides by the courthouse.

THE HAUNTING

Records show that after her husband died, Elizabeth lived most of her life at Oak Lawn before leaving for Baltimore, where she died in 1887. Edwin, Elizabeth and their seven children weren't the only earthly and perhaps eternal inhabitants of the stone townhouse on Mount Misery. The 1860 U.S Census records the presence of an African American servant, Jane Hinson. Likely born into slavery in 1837, this twenty-three-year-old woman was keeping house during the time Oak Lawn was being run as a "female seminary"—essentially a boarding school that offered the equivalent of a four-year college program to young ladies before the Civil War.

Many believe that Edwin, their children and, more intriguingly, their servant may still be watching over the house and tending to the needs of their living houseguests from beyond the grave.

The reports of strange occurrences at Oak Lawn began in the 1970s, when the building was home to the district court and the Howard County Office of Parole and Probation. Clerks and secretaries working in the building relate accounts of lights inexplicably turning on and off by themselves. They tell of a coffeepot that would heat up long after the pot had been unplugged and of doorknobs that mysteriously turned by themselves. Many were unnerved by the sounds of phantom footsteps and ghostly laughter in unoccupied rooms of the building. Some even heard the entities call them by their given names. An employee working in an office on the third floor once looked up to see a rocking chair slowly

rocking back and forth and hearing the floorboards creak under the weight of the unseen rocker.

Many of these manifestations have been observed in broad daylight. A staff member who came in to work early one morning before she thought anyone else had arrived was startled to see the figure of a man gliding down the stairs as she approached the window of the front door. A check of the building revealed that no one was inside.

Despite the frequency of daytime sightings, the entities seem to be most active at night. A past district court commissioner reported numerous eerie encounters with whatever or whoever lingered at Oak Lawn. One evening, when he was working alone in the building at one or two o'clock in the morning, he stood stunned as he watched three cloth napkins set out for an event the next day slowly unfold and then refold themselves in front of his eyes.

But even that eerie experience wasn't as disturbing as the night the former commissioner saw what he believes was one of the ghosts. As he was climbing the stairs to the second floor of the building, he saw something out of the corner of his eye. He turned to see a white haze that formed a misty ball of vapor floating up ahead of him on the stairs. Although it seemed very solid and dense, he could somehow see through it. Just as he was registering what he might be seeing, the orb suddenly vanished.

Unlike many staff members who refused to work alone in the building at night, the commissioner said that the ghost didn't bother him. He explained, "When you're dealing with criminals and drunks, ghosts are the least of your worries. I was always much more concerned about what a living person might do to me than a dead one."

Another after-hours experience involves a sighting by a security guard. While patrolling the lower level of the building, he reported seeing the apparition of a woman near one of the windows. Based on her gestures and movements, the guard said she appeared to be cooking. This is where the signature manifestation of the Oak Lawn ghost comes into play.

According to those who know the building best, the smell of cooking seems to haunt the house even more intensely than do the otherworldly sights and sounds.

Despite the fact that there hasn't been a kitchen in the building since the county purchased the building in 1937, staff members, visitors and contractors alike have reported the savory scent of simmering soup, sizzling bacon, frying eggs and even apple cobbler wafting through the building. The mouthwatering smell of delicious food being served up

by the notorious "Cooking Ghost" starts in the morning and continues throughout the day and into the evening.

Although the exact identity of the entity is not known for sure, one can make an educated guess about who the Cooking Ghost might be. It's doubtful that Edwin Parsons Hayden, who was a prosperous lawyer and county clerk, would have remained behind in the afterlife to putter around in a ghostly kitchen. Likewise, the well-off lady of the house in the nineteenth century probably rarely, if ever, prepared a meal with her own hands. She would have had servants to tend to those chores. Perhaps the Cooking Ghost is the industrious entity of Jane Hinson, who faithfully rises every morning to prepare breakfast for the long-dead Hayden family and the pupils of the Oak Lawn Seminary for Girls.

Whether or not you believe the house is inhabited by the ghost of Edwin Hayden, the playful spirits of his children or the spirit of the family's African American servant, one can't help but be impressed by the persistence of the legend of one of Ellicott City's most famous haunted sites.

First Presbyterian Church

SOMETHING WICKED WANDERS BENEATH THE SIGNATURE SPIRE ON THE TOWN'S ICONIC SKYLINE.

Now home to a treasure trove of exhibits and artifacts belonging to the county's most notable families, the First Presbyterian Church, which now houses the Museum of Howard County History, has loomed over the town for more than one hundred years. Today, tourists climb the hill to enjoy the programs presented by the Howard County Historical Society, which now owns the site. They always get a fascinating glimpse of history and, sometimes, something darker.

THE HISTORY

Initially organized in 1839 at Ilchester, the First Presbyterian Church moved to Ellicott City to make room for its growing congregation. They chose a site high on a hill next to the new courthouse and began the construction of a simple but stately Greek Revival stone building in 1842, completing it in 1844. The front of the building featured two entrances, one on the right for men, the other for women. At the time of construction, Reverend S. Guiteau was the pastor.

Over the next fifty years, the church rolls continued to swell beyond the capacity of the relatively small building. This time, instead of relocating, the church fathers decided to simply renovate and enlarge the sanctuary.

The original church building, constructed in 1844, collapsed in 1893 during renovations to expand the structure. *Howard County Historical Society*.

The project came to an unfortunate end in April 1893, when workmen excavating the basement caused the front of the building to collapse. An account of the "severe disaster" appeared in the *Ellicott City Times*: "They had partially completed their work when a suspicious noise was heard above and they left their work to make an investigation. Before they got around, the entire front of the building came down with a crash. The workmen, who were William Brian and Joseph Myers, masons, Alfred and Alle Williams, colored laborers, were astonished and gratified as, had they remained a moment longer they would have been buried in the debris."

With most of their church in ruins and wondering what to do next, the congregation decided to call in Baltimore architect George Archer for a consultation. Based on his recommendation, the congregation voted to demolish the remaining walls and build a new church on the site.

An article in the *Ellicott City Times* in 1894 described the church Archer had designed: "The style will be Gothic with a tower." A later description added more detail, noting that the church

*will be of granite using the stone of the old building as far as it will go.
The main auditorium will be 32 by 58 feet to be connected with sliding*

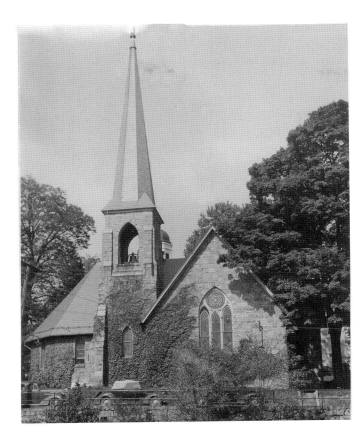

The First Presbyterian Church high on Capitoline Hill/ Mount Misery is now home to the Museum of Howard County History. Photo circa 1930s. *Howard County Historical Society.*

doors to the Sunday School room which will form an octagonal wing. When thrown into one there will be seating for 200 people. The tower will be granite part way up and end with a spire rising 100 feet. The roof will also be of slate. The interior of the church will be finished with oiled white pine with a ribbed plaster ceiling. There will probably be several memorial windows. The entire cost of the church will be about $8,000.

The new church with the soaring steeple was completed in well under a year and was dedicated on December 23, 1893.

In 1913, the original organ was replaced by one built by A.B. Felgemaker in Erie, Pennsylvania. As impressive as it was, the massive pipes of the new instrument unfortunately hid a round stained-glass window set up high on the wall behind the pulpit. Visitors who know what they're looking for can open the door next to the organ and peer up at the glass, which features a dark blue field with two cherubs, one with a horn and one with what appear

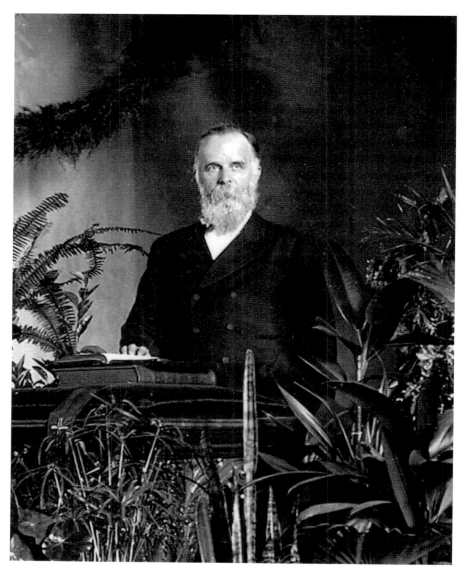

The Reverend Henry Branch took over pastoral duties at the church in 1882. *Howard County Historical Society*.

to be cymbals. The window is said to have been installed as a memorial to two of Reverend Henry Branch's children who died as infants.

Less than one hundred years after the church was started, the First Presbyterian Church's congregation once again grew too big for its building, they put the Ellicott City landmark up for sale in 1960. Alda Hopkins Clark, who founded the Howard County Historical Society in 1958, bought the building and donated it to the organization as a memorial to her husband, Judge James C. Clark Sr. Now known as the Museum of Howard County History, the building is filled with the society's permanent collection and routinely bustles with activities as well as a host of ghostly presences.

The Haunting

Anyone who has been a longtime member of the Howard County Historical Society or a frequent visitor to the museum knows about the profound sense of creepiness people experience in the building's basement.

Originally the site of what could have been multiple fatalities when the first structure collapsed in 1893, until just recently, the lower level was where the building's only bathroom was located.

Back then, anyone who had to use the facilities had to descend a long flight of stairs into the dark depths beneath the sanctuary. They then would hurriedly walk past a darkened office and thread their way through a maze of sheet-cloaked antique furniture and historic fixtures that were stored down there. When they finally reached the tiny toilet area, most hurriedly flipped the light on and quickly closed—and locked—the door. When they were ready to leave, more than a few paused a moment to gather their courage before briskly retracing their steps through the shifting shadows they felt closing in on them.

Who or what could be down there? And why? Outside of funerals, this house of worship was a place of celebration and fellowship. Of course, a few steps down the hill was a much darker place, Willow Grove/Emory Jail, or the old Ellicott City Jail.

There, just a short stroll down Court Avenue, was the place on Mount Misery where the handful of Ellicott City hangings were conducted. They were spectacles that would draw young and old alike to watch and wait for the gruesome "entertainment" to begin. Perhaps some of the doomed

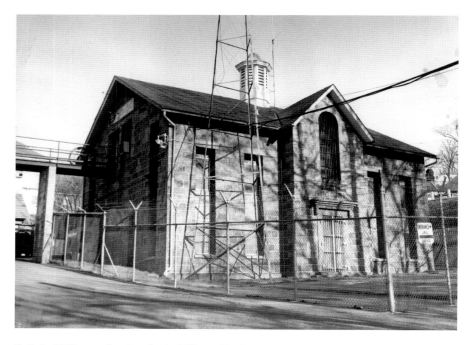

Built in 1878 near the church, the Ellicott City Jail had "dark cells" where condemned prisoners waited for their morning executions. *Howard County Historical Society.*

souls decided to seek refuge in the church basement after the hangman did his duty.

Whatever the source of the spirits, evidence of their existence presents itself on an ongoing basis. Strange sounds have been heard emanating from the ceiling in the downstairs office; objects mysteriously fall off desks before the eyes of unnerved volunteers. Fogs of frigid air frequently float through the sanctuary, where, sometimes, the faint notes of a woman singing seem to drift in from far away. Other experiences, however, aren't quite so benign.

A museum manager rearranging items near the stove that used to be part of the former Bell and Quill lunchroom in the basement was startled by an unseen something or someone who scratched his neck so hard it left marks that were captured by a paranormal investigator's camera.

Once, a few years after the bathroom had been relocated to the main floor of the museum, a couple attending a concert decided to go down to look around after the performance. The husband was hesitant. He'd always felt uneasy when he had gone down to use the restroom in the past. His wife egged him on, and they ever so slowly edged down the steps into the pitch

The Sunday School Room that opens to the sanctuary. The railing along the stairs that lead to the haunted basement is at far left. *Howard County Historical Society.*

blackness below. Suddenly, he sharply drew in his breath and stopped dead in his tracks just short of the office that always seemed to be the center of psychic energy.

Despite his wife's urging, the husband flatly refused to take another step toward the room's inky opening. "There's someone in that office," he said, pausing. "And they *want* something."

At that point, the hairs stood up on both of their necks. They spun on their heels and ran back up the steps. Neither one of them wanted to know what the presence was or what terrible thing it might demand from them. They left knowing that they would never go back, even in the daylight, to look for what was lurking in the depths of the museum's basement.

ANGELO'S CASTLE

VENGEFUL GHOST IS SAID TO DRAG VICTIMS TO THEIR DEATHS IN THE PATAPSCO RIVER.

SUPPOSEDLY NAMED FOR MICHELANGELO AND variously known as Castle Angelo, Angelo's Castle, Angelo's Cottage and the Chateau, the Ellicott City landmark located on Church Road perches on a rocky ledge overlooking the town and the Patapsco River. Although it is one of the most notorious haunted houses in the area, this neo-Gothic architectural gem has long been shrouded in the mystery of its origins and stories of an artist-loving ghost that doesn't like to be crossed.

THE HISTORY

Best viewed from the Baltimore County side of the Patapsco River, Castle Angelo was built on land originally owned by brothers George, Samuel, Andrew and John Ellicott. The identity of the man who constructed it has, until now, been murky to say the least.

According to local lore, the man who built Angelo's Castle was a French artist named Samuel Vaughn. As romantic as the legend is, there are no historical records to support the claim. A report in a 1972 issue of the *Maryland Journal* featured an article reprinted from an earlier 1833 publication, claiming that the castle had been built by Alfred S. Waugh.

So, who was the first owner and builder of Castle Angelo?

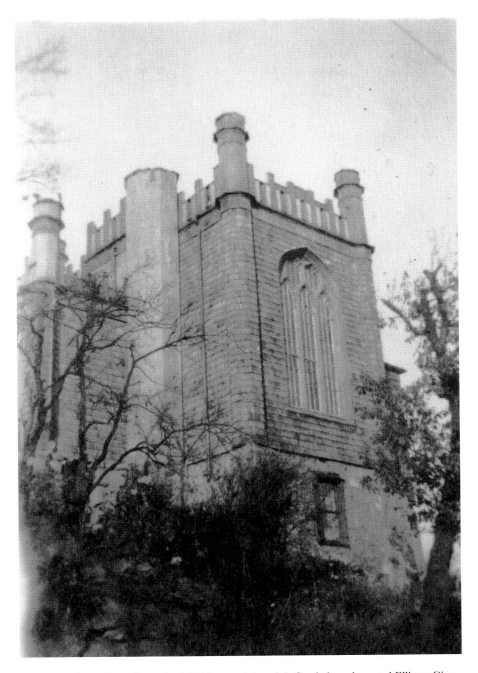

Unanswered questions about the inhabitants of Angelo's Castle have haunted Ellicott City for nearly two hundred years. *Howard County Historical Society.*

The Maryland Inventory of Historic Sites says that in 1830, Andrew and George Ellicott sold their property on the north side of Main Street to Andrew McLaughlin of Baltimore for $15,000. That property included 8060 Main Street, the Patapsco Hotel building and the lot where Castle Angelo would be built by McLaughlin and his Baltimore architect, Alfred S. Waugh.

Obviously inspired by European rather than the popular Classical Revival architecture of the early 1800s, Waugh and McLaughlin designed Castle Angelo as a one-of-a-kind Gothic Revival, one-story, wooden frame structure built on a stone foundation. The rooms in the original design were laid out in a cross-shaped floor plan. At various points in time, the building has been clad in stucco, wood shingles, aluminum siding and, currently, a stucco-like material.

To reach the home's double Gothic paneled front door, which was originally its back door, visitors today descend thirty-one steps from its parking lot off Church Road. The focal point of the castle's interior is the chapel room with its large arched window that looks out over the Patapsco River valley. In later years, a bedroom was added above the chapel, which cut off from view the top of the arch.

The original dungeon-like basement of the building used to be accessed by a narrow stairway off what now is the home's foyer. The most recent owner closed the stairway and installed a half bath there. She created a new stairway down to the lower level from the chapel room. The formerly unfinished basement now houses two bedrooms, a sitting area and a laundry.

When the house was first built, the front door was located on the lower level, where a steep flight of stone stairs led down to the railroad tracks and the B&O Railroad Station. In the mid-1800s, the B&O Railroad conducted special excursions to Ellicott City from Baltimore so passengers could look up and marvel at the unique home on the hill above the tracks.

Over the years, the home has undergone many reconfigurations, so it's nearly impossible to know exactly what it looked like when Andrew McLaughlin first lived there. What we do know is that he didn't live there for long.

After his purchase in 1830, McLaughlin immediately started making major improvements to the Patapsco Hotel and built a three-story house at 8060 Main Street, where he lived while laying out plans for Castle Angelo. The cornerstone for the hilltop home was laid in June 1833, but McLaughlin may have never actually moved in.

His real estate endeavors were evidently a little too ambitious, and he quickly got into financial trouble. Within three years of his purchase, he was looking for a way to get out of his financial bind and came up with a clever plan. He petitioned the Maryland General Assembly for authorization to hold a lottery in which he'd collect money from the participants to settle his debts, and the winners of the lottery would get his real estate and personal property as prizes. The assembly passed McLaughlin's petition in 1833, and the lottery was first advertised in February 1834.

The McLaughlin 1834 lottery advertisement featured a magnificent engraving of the properties, including Castle Angelo as seen from Rock Hill College, by Baltimore architect Robert Carey Long Jr.

The most valuable of the lottery's four hundred prizes was the Patapsco Hotel, which was estimated to be worth $36,500. The next prize was the house at 8060 Main Street, valued at $3,000. After that came "Angelo's Cottage," described in an announcement in the Leesburg, Virginia newspaper *Genius of Liberty* (volume 18, Number 30, July 26, 1834) as "a beautiful Gothic cottage, situated upon a ledge of rocks, overlooking the village," which was valued at $2,650. In addition to this real estate, other prizes included lots valued at between $200 to $800, as well as silver, books, furniture and bottles of wine.

Lottery participants paid ten dollars per ticket for the chance to be the "fortunate adventurer who will be in full possession of one of the most delightful, romantic, and healthy pieces of property within the borders of the United States."

The lottery was held on a Saturday morning in September 1834. According to the December 27 issue of the *Genius of Liberty*, the winner of the Patapsco Hotel was Joseph Barling of Baltimore. Robert Campbell, the lamplighter at the Patapsco Hotel, won the house at 8060 Main Street. A total of fifty-six people purchased tickets for the third prize, "the elegant Angelo Cottage." The winning ticket was number 48, held by thirty-one-year-old U.S. Navy lieutenant Cadwalader Ringgold.

Born in Hagerstown, Maryland, at Fountain Rock, his family's eighteen-thousand-acre estate, the wealthy Lieutenant Ringgold probably sold the castle shortly after the sale, since no record was found of him or his family ever residing in Ellicott City.

So, to whom did Ringgold sell the castle? Records at St. Paul's Catholic Church in Ellicott City say that Castle Angelo's owner allowed the first pastor, Father Henry Coskery (1835–1839), to celebrate Mass in the castle's chapel before the church was completed in 1838. Records also say that the castle was used as a rectory for St. Paul's.

Since at that time a non-Catholic would have been unlikely to have offered up his home for Mass or housing for a priest, the first owner to live at Castle Angelo was probably William J. Pamphilion.

In the early part of the 1800s, Pamphilion was working as a carpenter on the construction of St. Charles College on the outskirts of Ellicott City. Records show him as the owner of the castle in 1843. Seven years later, the 1850 U.S. Census lists William and his wife, Amelia, along with daughters Anne, Helen and Mary and son James, as residents of Ellicott City. According to records at St. Paul's Catholic Church, Helen was baptized there in 1841.

Local legend steps in once again to claim that, sometime during the Civil War, a Reverend Moore owned Castle Angelo. Emory Methodist Church is located just down the hill from the home. Between 1843 and 1878, when the next historical record of the home's ownership turns up, a succession of eighteen pastors served at Emory. None of them were named Moore.

In 1878, the G.M. Hopkins atlas identifies William Lawrence as the owner of Castle Angelo. The next recorded owner was John T. Ray. He served as the warden of the Howard County Jail, which was a block or so away from the castle. The 1880 U.S. Census shows him living at the county jail with his wife, Mary Elizabeth, and daughters Laura, Josephine, Jane and Roberta, as well as their son William Calhoun. They may have purchased Angelo's Castle later that year.

Mary Elizabeth died on May 5, 1894. Ray lived another eleven years, dying on September 20, 1907. Heirs of the Ray family sold the home at auction to Samuel H. Watkins in 1912.

Watkins, who worked as a telegrapher at the B&O Railroad Station in Ellicott City, lived at the home with his wife, Clara Blanch, along with their son Noble and daughters Ella, Clara, Virginia and Olivia. The siblings turned over the house to Virginia in the late 1950s. Virginia Hazel, her married name, was an artist who taught art to individuals at her home and gave lessons to children at Emory Methodist Church during the summer. She remained in the home until 1967, when she deeded it to James Maurice Fields and his wife, Blanch Fay, who may have been a relative of hers.

Mr. Fields was a mortician at William J. Tickner and Sons Funeral Home in Baltimore; according to one of his daughters, "Needless to say, Halloween was a lot of fun there!" Unfortunately, Fields died in 1969, just two years after the family moved into the home.

In 1971, Mrs. Fields sold Castle Angelo to Dutch artist Peter van Rossum and his wife, Gerda. The couple had moved to Maryland from the Netherlands, where van Rossum's world-famous family made glazed

ceramic Delftware. From 1967 to 1985, van Rossum was the owner and artist in residence at the Delft Gallery near Ellicott City, where he hand-crafted rare black Delftware dishes, vases, clocks and tiles. Records show that van Rossum also created a beautiful blue Delft tile surround for the massive fireplace on the west wall of the castle's cathedral room. The fireplace and the surround have since been covered.

The castle changed hands again in 1984, when the van Rossums sold the home to Louise and James Kealy. They and their five children lived in the home for almost ten years, during which time the Kealys divorced. Louise went on to marry Archie Minneman perhaps in the early 1990s. The Minnemans lived there until 2005, when Louise sold it to local realtor Kimberly Kepnes, who extensively renovated the property.

THE HAUNTING

Of all the spirits that may haunt Angelo's Castle, the most mysterious by far is "Monsieur" Samuel Vaughn. Identified in many documents as the builder of the home, Vaughn is a nebulous figure who, nevertheless, is often described in vivid detail. It's said that he was a French artist who designed the home as a replica of one in the south of France. Legend has it that he traveled away from his home in Ellicott City frequently and eventually left the area because it was becoming too urbanized.

Again, legal records uncovered to date don't list Vaughn as an owner of the castle or as a resident of Ellicott City. But the stories are so persistent and widespread that it seems there must be something to them. Perhaps Vaughn was an early visitor to the castle who was so entranced by the home that he decided to come back and take up permanent residence as a ghost after his death.

The stories about Samuel Vaughn gave rise to the legend that says as long as an artist lived at Angelo's Castle, its ghost would remain happy and at rest. But woe to any non-artist who dared to live in the home. According to the story, the offended ghost would wait for an opportune moment, perhaps in the middle of a moonlit night, to stretch out its skeletal hand and seize the disrespectful soul by his nightshirt and drag him down the original narrow back stairway into the dank, dark dungeon beneath the home. Once there, the vengeful spirit would open the castle's back door and fling the freshly murdered or terrified still-living victim down the steep

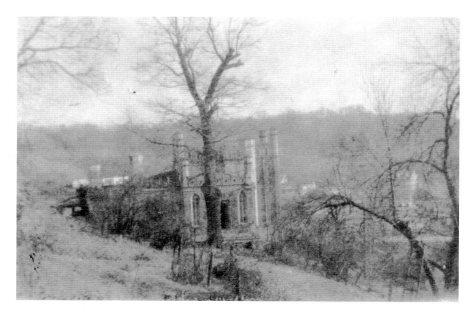

While the original grounds were described as beautiful, they fell to ruin in the 1930s. Today, they are completely restored. *Howard County Historical Society*.

stone steps and into the river below. Dead bodies that occasionally washed up on the banks of the Patapsco in the nineteenth century added fuel to the fire of this ghastly legend.

Another story about the previously mentioned Reverend Moore says that he was the first owner to experience odd occurrences and strange noises at the home, during the time of the Civil War. Moore is said to have made architectural changes to the original cruciform layout of the castle that the ghost was unhappy with. The story also claims that the home was a stop on the Underground Railroad and that Moore hid slaves and helped them escape down the back steps to the river and railroad tracks below. Some even contend that Reverend Moore is one of the spirits that roams the halls of the home. According to that story, Southern sympathizers murdered Moore for his kindness to runaway slaves and then buried his body beneath the dungeon's floor.

In the twentieth century, the spirits seemed content to simply move objects around from time to time or whisper softly in the night. Perhaps they were happy because Virginia Watkins Hazel, who lived most of her life in the home, and Peter van Rossum were artists.

It does bear noting, however, that as recently as the early 2000s, when one of the most recent owners took possession of Angelo's Castle, she found herself waking up at precisely 3:00 a.m. night after night. Spooked by her experience, she asked the woman she bought the home from if she thought her dead-of-night awakenings were "just her" or the house. The immediate reply was, "It's the house." A short time later, when the Howard County Historical Society asked that same owner if she'd let them conduct a paranormal investigation at the castle as a fundraiser, she declined, saying, "Things have just started to calm down around here."

Although the mystery of Angelo's Castle's phantom owners, violent ghosts and romantic legends may never be solved, the stories of this Gothic architectural gem continue to frighten and fascinate all who dare to delve into its dark past.

MT. IDA

EIGHT OF THE MANSION'S OWNERS TOOK TO THEIR DEATHBEDS. ONE NEVER LEFT.

DEFENDANTS AND PLAINTIFFS WHO'VE COME and gone at the Howard County Courthouse over the years have no doubt noticed the handsome yellow mansion just past the edge of the parking lot. Few, however, have ever been inside 3691 Sarah's Lane, which was a private home for more than 130 years, a near ruin for decades and eventually renovated as commercial space. Now the headquarters of two local historical organizations, the mansion known as Mt. Ida occasionally opens its imposing doors to the public for events and tours. Afterward, when the staff locks up, they know that Mt. Ida is in the safe hands of its namesake ghost—who has her own set of keys.

THE HISTORY

Sited high on a hill with a spectacular view of the Patapsco River valley, Mt. Ida was built in 1828 for William Ellicott, the grandson of Andrew Ellicott, who was one of the founders of Ellicott City.

The last home built by an Ellicott family member in the historic district, this Greek Revival mansion was designed by well-known Baltimore architect Robert Carey Long Jr. and constructed by Charles Timanus. Built of granite and rubble covered by a coating of sand and mortar stucco marked off to look like distressed stone, the simple but stately design reflects both the Ellicott family's history of Quaker plainness and their wealthy status.

Sadly, Ellicott and his wife, whom he married in 1833, didn't get to enjoy the beauty of his lovely home for very long. He died just eight years after it was built, on March 22, 1836, at the age of forty-two and was buried nearby in the Ellicott family cemetery. The home was then sold to attorney John Shoemaker Tyson and his wife, the former Rachel P. Snowden.

The 1860 U.S. Census shows Judge Tyson living there with his wife; mother-in-law, Anna M. Hopkins; son John; daughters Cornelia, Anna and Ida; as well as Mary McKenzie, who is listed as a seamstress. Six years later, Tyson died on October 3, 1864. He was followed in death by his wife, Rachel, on May 2, 1889. Their son John Snowden, who was also an attorney, died in a terrible boating accident on the Susquehanna River a year later. Their three unmarried daughters remained in the home for the rest of their lives.

"Miss Ida," as she was known, inherited the home after Anna, the second of her two sisters, died in 1895. Although she became deaf in her later years and walked with a cane, Ida was reported to be "spry and agile and surprisingly self-sufficient."

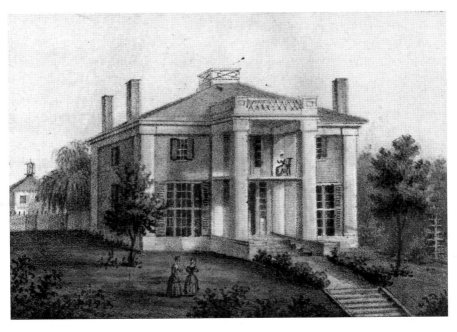

Mt. Ida at the height of its glory, showing the balcony and widow's walk—Miss Ida's favorite haunts. *Library of Congress Historic American Buildings Survey.*

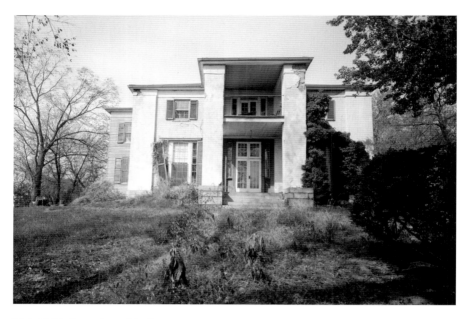

This 1964 photo shows Mt. Ida well on its way to being scheduled for demolition. Fortunately, it was saved. *Library of Congress Historic American Buildings Survey.*

In 1915, Ida's second cousin Adelaide Snowden Hodges moved in with some of her six children to care for the last surviving member of the Tyson family. According to Mrs. William Snowden Hodges Jr., who lived there from 1920 to 1921, "If lucky, one might meet Cousin Ida with her keys, and if it were her pleasure, she would escort you to the little widow's walk atop the house where the view was even greater."

With the help of her family, Ida lived in her ancestral home until she passed away in 1925 at the age of eighty-five. After her death, Louis Thomas Clark and his wife, Desiree Branch Clark, bought the property in October 1930 and moved in with some of their eleven children, including Louis, Henry, James, Millicent, Mary, Desiree, Charles, Marian, Nathan, Basil and Betsey.

The Clark family lived at Mt. Ida until Louis's death on December 3, 1957. The property was then sold in 1959 to "business interests," who planned to demolish it. The formerly majestic home stood empty for years, was vandalized and braced for the coming of the bulldozers until the 1970s, when it was purchased by the Miller Land Company and turned into an office building for the *Howard County News*.

It later served as the visitor's center for the Patapsco Female Institute Historic Park and was twice featured as a Decorator Show House for Historic Ellicott City Inc. Today, it serves in its magnificently restored state as the headquarters of Historic Ellicott City Inc. and the Friends of the Patapsco Female Institute. The beautiful Ellicott mansion on the hill has survived to share its history and perhaps traces of its past inhabitants with anyone who enters its still beautiful parlors, halls and bedrooms.

THE HAUNTING

A historic house like Mt. Ida is bound to have a ghost or two rattling around its grand rooms, especially since so many of the home's owners died during their time at the mansion. No records of what the relatively young William Ellicott died of could be found. However, like most people of that era, he most likely died at the home.

Over the years, the entire Tyson family passed away while at Mt. Ida, starting with Judge John Shoemaker Tyson in 1864 and ending with the death of his daughter Ida around 1925. The last owner, Louis Thomas Clark, left the house via hearse in 1957.

Long-dead owners who can't bear to leave await visitors in the mansion's now-restored grand parlors. *Library of Congress Historic American Buildings Survey.*

But of all the souls who departed life during their time at the mansion, it's said that it is Miss Ida who has stayed behind to keep a spectral eye on the only home she ever knew. Visitors and staff members who've stayed past dark say they've heard the creaking of floorboards and the telltale sound of the jingling of keys whenever Ida makes her presence known. Some have even seen her apparition on the porch above the portico gazing out at the spectacular view. Whatever their experience, everyone who's had an encounter with her reports that Ida's ghost is a friendly one who no doubt is pleased that the home she loved so much still stands on the hill above Ellicott City.

PATAPSCO FEMALE INSTITUTE

A GHOST STORY BEGINS WHERE A GIRL'S LIFE ENDS AT THIS FORMER FINISHING SCHOOL.

THE FIRST TIME MOST PEOPLE hear the name of what are now stabilized stone ruins on the highest hill above Ellicott City, they assume that the Patapsco Female Institute must have been some kind of insane asylum for women. The truth is much more interesting. Originally built as a finishing school for wealthy southern belles, the Greek Revival building at 3655 Church Road has been reincarnated many times as a hotel, a private residence, a theater, a veteran's hospital, a collapsing ruin and, finally, a historic site and county park. Of the thousands of people who have passed through the building's doors during its life and theirs, a few seem to have remained behind after their and the once-beautiful school's demise.

THE HISTORY

In the earliest days of Ellicott City, girls and boys were educated together. But as the town grew and the need for additional educational facilities became apparent, prominent members of the community acquired twelve acres of land and chartered the Patapsco Female Institute in 1834.

Baltimore architect Robert Cary Long Jr. designed the school, which was constructed by Charles Timanus using locally quarried cut and dressed rare yellow tinted granite. Costing a little more than $16,600 to build, the

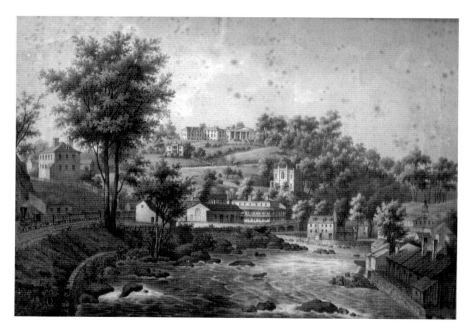

This 1857 E. Sachse & Co. print shows the Patapsco Female Institute on the highest hill overlooking the town. *Howard County Historical Society.*

original fifty-seven-room structure was erected to accommodate eighty to one hundred students aged twelve to eighteen.

The Patapsco Female Institute opened on January 1, 1837. At the time, it was thought that women would be somehow spoiled by higher education, so the fact that the school offered women the opportunity to take classes in foreign languages, mathematics, music, religion and philosophy was revolutionary in many ways.

Tuition was set at $120 per twenty-two-week session, which included board, "washing, use of bedding and other incidental expenses." The school charged extra for the use of musical instruments, drawing and painting classes and instruction in Latin, Greek, French, Spanish, Italian and German. Poorer students could provide physical labor to reduce their tuition.

In 1841, Almira Hart Lincoln Phelps took the helm of the Patapsco Female Institute, which expanded and prospered in the years leading up to the Civil War. Between the time she started and 1855, when she left, the school grew from a faculty of six teachers with forty-one students to eight teachers and nine staff members with seventy students.

This portrait of Almira Hart Lincoln Phelps, who served as the institute's principal between 1841 and 1856, hangs in the Museum of Howard County History. *Steve Freeman.*

Wealthy southern plantation owners sent their daughters to the school in droves. Listed among its most famous alumnae were Winnie Davis, the daughter of Jefferson Davis, as well as Alice Montague, the mother of Wallace Warfield Simpson, the Duchess of Windsor. Thomas Jefferson's great-granddaughter Sally Randolph served as the last headmistress of the school.

Unfortunately, the institute's fortunes declined in the years after the Civil War. It finally closed its doors in 1891, when it was purchased by James E. Tyson, who turned it into a summer hotel. In 1905, the building was purchased by Tyson's daughter Lilly, who renamed it "Burg Alnwick," after the ancestral castle home of the Tyson family in England.

It's said that Lilly restored the building to its former glory, filling it with beautiful antiques. She later opened it to the public as an exclusive summer inn.

In 1917, the building was converted into the fifty-bed Maryland Woman's War Relief Hospital to care for returning wounded World War I veterans. It was sold in 1930 to owners who later leased it to Donn Swann Jr. between 1938 and 1941. Swann converted the ballroom into the two-hundred-seat Hill Top Theatre, which hosted more than thirty summer-stock theatrical productions.

Later, in 1943, the institute was purchased by Manola Brennan of Washington, D.C., who wanted to turn it back into a "luxurious retreat." Her plans fell through, and she ended up renting it to Michell Gould, who ran

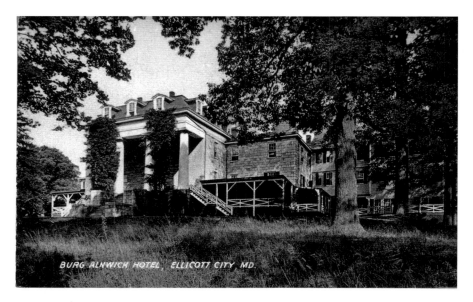

Added onto and expanded, the building opened its doors to visitors as the luxurious Burg Alnwick Hotel in the early twentieth century. *Howard County Historical Society.*

a nursing home for the poor between 1953 and 1956. Brennan's daughter Faye inherited the property after her mother's death in 1955 and kept it until 1958, when she sold it to Dr. James Whisman, who wanted to continue to use the building as a nursing home.

Those plans were derailed by the Howard County building inspector, who cited the structure as a firetrap and required Whisman to have all of its wooden parts removed. He complied by gutting the building and selling all of the contents, including the beautiful paneled walls, floor, mantels and shutters, to a wrecking contractor. The lovely old institute gradually fell into ruin. When Whisman died in 1965, he willed it to his alma mater, the University of Cincinnati.

By then, many citizens began clamoring for what remained of the building to be purchased by the Howard County government. In 1966, they got their wish when the county commissioners purchased it for $17,500. Plans were drawn up for the complete restoration of the structure, projected at the time to cost $500,000. The project sputtered out, leaving the massive structure to crumble.

What was left of the dismal shell of the building was cared for by the Friends of the Patapsco Institute. Over the years, the group fenced it in, in

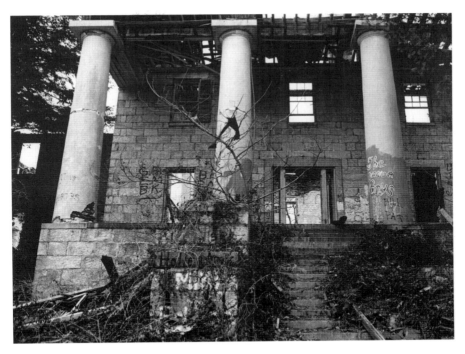

By the 1970s, the once-majestic building was a ghost of its former self, covered with graffiti and buried in trash and debris. *Howard County Historical Society.*

an unsuccessful effort to keep vandals out. In 1978, the institute was listed in the National Register of Historic Places and the Maryland Register of Historic Properties. Nevertheless, the property—roof-less, deteriorating and damaged by several fires and years of neglect—remained closed to the public.

By the time Howard County was finally ready to fix it up, a full restoration wasn't feasible. Engineers stabilized what was salvageable, and the county spent $1.7 million to convert the Patapsco Female Institute Historic Park, which opened in 1995. In 2002, the Chesapeake Shakespeare Company brought live theater back to the venue with summertime, picnic-friendly performances of Shakespeare's plays. The site has continued to be improved and now hosts everything from tours and historical presentations to weddings and other special events, including a ghost tour that tells of a student who was dying to go home but never did.

THE HAUNTING

By its very nature, a boarding school is often a place of wistfulness and sorrow. Over its nearly sixty-year history, the Patapsco Female Institute was likely drenched in the tears of homesick girls who missed the warm climate and carefree childhoods at their plantation homes across the South.

It's said that a young girl named Annie Van Derlot was one of them. During her first semester at the school, she wrote home, complaining bitterly about what she called her "incarceration" at a school that required girls to follow a rigid code of conduct, which insisted that they keep their voices low and their opinions on public matters to themselves.

Although it is not located in the far north, winters in Maryland can be cold. Those accustomed to the balmy winters of Alabama or South Carolina often didn't bundle up as warmly as they should. The sick shared unsanitary chamber pots, which likely helped the spread of influenza, strep throat and croup.

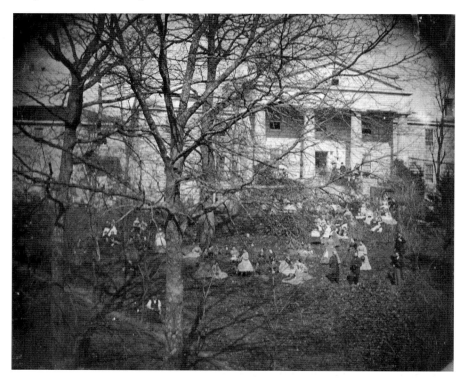

Here, dozens of young ladies aged twelve to eighteen are pictured on the school's front lawn in the mid-1800s. Was Annie among them? *Howard County Historical Society.*

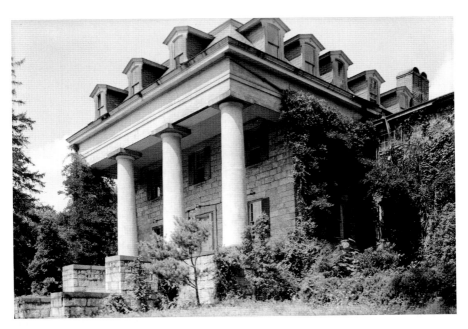

This 1936 photo shows the mansard roof and dormers that were late-1800s modifications to the building. *Library of Congress Historic American Buildings Survey.*

It isn't known if she caught a chill on the windswept hill where the institute stands or in the building's cold basement where music lessons were conducted. But at some point during her first winter there, Annie caught a cold that worsened over a few weeks and eventually turned into pneumonia.

Before she got too weak to write, she penned a final letter home begging her parents to come and get her. It arrived just days before her parents received a second letter from the headmistress saying that Annie had died.

After her death, her parents granted Annie's last wish and took her body home. But the Patapsco Female Institute wouldn't let her spirit go. Whether her ghost appeared in later years to wealthy Baltimoreans who spent their summers at the hotel, the wounded veterans at the war hospital or theatergoers isn't known.

What is known is that today, many visitors have reported being startled by the sensation that an unseen presence is creeping up behind them. People have encountered cold spots, heard unexplained ethereal music and seen an eerie blue light flickering in the top-floor windows. A few have even seen Annie.

One report from a girl who was visiting the Patapsco Female Institute Historic Park and got separated from her tour group describes a sighting in disturbing detail. It seems she was standing in front of the school, deciding which way to go to find her group, when something caught her eye.

It was the figure of a young girl dressed in a flowing gown who walked out of a door, across a porch and then down the stairs to the lawn, where she vanished. Looking up to retrace the path of the ghost, the girl noticed that the "porch" the apparition had seemed to cross had been torn down long ago and that now nothing was there.

While the porch and most everything else Annie must have experienced in her short time at the Patapsco Female Institute are gone, her spirit remains eternally waiting for her parents who didn't get there in time to take her home.

PART III

DARKNESS ON THE EDGE OF TOWN

SEVEN HILLS ROAD

CHILLING ENCOUNTERS WITH A DEMON-DRIVEN TRUCK AND OTHER ENTITIES THAT ROAM COLLEGE AVENUE.

NAMED AFTER A PRIVATE BOYS' school that burned to the ground in 1922, College Avenue, locally known as Seven Hills Road, is a twisting, two-lane road that begins at the intersection of St. Paul's Street and New Cut Road. Winding its way up a steep incline, the road then straightens out over a series of seven hills where generations of local teenaged drivers have come to seek thrills and where more than a few have met their deaths.

THE HISTORY

Originally little more than a lane that led up to the haunted Lilburn mansion, the north end of College Avenue was where Rock Hill College once stood. It was founded in 1822 as Sams Academy and purchased in 1857 by the Institute of the Christian Schools. In 1865, the construction of the massive cupola-crowned, four-story stone building that replaced a smaller building on the site was completed.

Rock Hill College was destroyed in the early 1920s when a fire burned the entire building except for the gymnasium. In 1925, the Ellicott City High School, which was built with stone from the ruins of Rock Hill College, opened its doors. From the 1930s to the '70s, the building was home to an elementary school. In 1991, it was converted into condominiums.

Farther up the hill, past Lilburn, a handful of late nineteenth-century homes line the road, which also runs past what was originally the Patapsco

College Avenue begins in front of where Rock Hill College once stood and runs south to Bonnie Branch Road. *Postcard from Author's Collection.*

Manor Sanitarium. Right about at the driveway to the old sanitarium, College Avenue's notorious run of seven hills begins. Until the land was developed in the early 2000s, the road ran through open fields and then into the blackness of a deep, dark forest. Silent except for the sounds of barred owls hooting in the night, it's a place where ghosts of animals and people lurk, as well as where a legend that has lured dozens to their deaths came to life.

THE HAUNTING

The stories of strange goings-on along College Avenue began in the 1960s, when residents reported seeing a Satanic black goat with glowing yellow eyes roaming the road. In the 1970s, tales of a "Demon Truck" began to be told.

According to those who lived to tell about their encounter with the murderous vehicle, if you race down this empty stretch of pavement at night and hit the seventh hill at the stroke of midnight, a jet-black demon truck or ghost car will suddenly appear out of thin air. Driven by a faceless entity, the

phantom vehicle is said to come barreling at whoever dares to go looking for it at one hundred miles per hour.

Most of the time, thrill-seekers evade the demon-driven auto, but far too often, they do not. Hundreds have been injured, and dozens of young drivers have been killed in crashes in which the car goes airborne over the seventh hill and crashes into trees in the depths of the forest.

Local papers and message boards are peppered with tragic tales of those who went looking for the demon truck.

"My brother Tim was one that lost his life on this road in 1971," local resident Barb Polihan wrote on an online message board. "He wasn't driving but with a group of teens that were joyriding. I can still see the picture of the twisted car on the cover of the *Catonsville Times*. Please don't try to hit the 7th or any of the hills at any time. This tragedy haunts me to this day."

If you drive down College Avenue during the daytime, you'll see that the trees alongside Seven Hills Road bear the marks of the countless car accidents that have occurred over the years. Many have resulted in deaths that have generated ghost stories of their own.

It's said that if you hit the seventh hill at midnight, a "Demon Truck" will appear, headlights blazing, barreling straight for you. *Shelley Davies Wygant.*

In July 1999, a couple was peacefully asleep in their College Avenue home near the historic district when suddenly, around midnight, the husband sat straight up in bed. "I heard a woman's blood-curdling scream," he remembered. "And then a horrible crash. The scream sounded like it was coming from someone who knew they were about to die."

Convinced the crash must have happened nearby, the couple threw on their clothes, got in their car and raced toward town. Based on the loudness of the scream and crash, they thought for certain that the accident had occurred down there. When they arrived at the intersection of College Avenue, New Cut Road and St. Paul Street, the road was empty and silent as a tomb.

The next morning, the couple awoke to the tragic news. It seems that twenty-year-old Amber Duncan of nearby Woodlawn had died in a violent car crash more than a mile away at the other end of College Avenue the night before.

According to Amber's twin sister, Katie, when she and her sister were in high school, they went "hill hopping" almost every night. So, she wasn't worried when her sister drove off with a friend that evening. Amber wasn't driving that night when her friend lost control of his 1987 Honda CRX on College Avenue. The car had gone airborne on the last hill, slammed into a tree and rolled over. At 11:45 p.m., Katie Duncan said, she felt a sharp pain in her stomach. It turned out to be at the time her sister had died.

Neighbors who live near where most of these accidents occur say they often rush out to help crash survivors. This time, one of them made her way to the crash site, where she says she bent over the body of a gravely injured young girl and found herself caught up short. "I literally felt a spirit rising up and through me, and I knew at that moment, she was dead."

As College Avenue has become more developed in recent years, fewer people have reported encountering the menacing Demon Truck. Instead, motorists have begun reporting sightings of a strange, cloaked woman standing in the middle of the road. By the time they spot the figure, it's already too late. Drivers say they are either forced to veer off the road or brace for impact, which never happens, because the apparition simply disappears.

When it comes to paranormal activity, whether it's in the form of demonic ghosts, sinister speeding trucks or forlorn women cloaked in flowing robes, College Avenue seems to get a lot of traffic. So, if you find yourself driving down this dark street around midnight, you might want to keep your eyes on the road and your hands on the wheel.

ILCHESTER TUNNEL

A FLICKERING SPIRIT ENGAGES THE LIVING IN A STARING CONTEST NO ONE CAN WIN.

NOT FAR FROM THE HAUNTED hills of College Avenue and the remains of St. Mary's Seminary is a portal that lets trains travel between Baltimore and Ellicott City. Bored into a cliff on the banks of the rushing river below, the Ilchester Tunnel draws daredevils to peer into the depths of the lair of local legend and the eyes of a ghost that won't let them look away.

THE HISTORY

At 1,405 feet, the Ilchester Tunnel is the second longest on the Baltimore & Ohio Railroad's Old Main Line. It was built in 1902–03 to bypass a sharp curve in the route that was used by the first horse-drawn carriage and ran from Baltimore to Ellicott's Mills.

The tunnel and a replacement bridge were built about four hundred feet upstream from where an earlier Bollman Truss span had been constructed in 1869 to replace the Patterson Viaduct, which had been partially destroyed in the great flood of 1868.

Named for Baltimore & Ohio Railroad director William Patterson and designed by Caspar Weaver, the massive granite Patterson Viaduct was built in 1829. It stood about 360 feet long and 43 feet high and featured four graduated arches. It is the only early B&O multi-arched stone viaduct to have been destroyed in a flood.

Stare if you dare into the depths of the Ilchester Tunnel before midnight to summon the Blink Man. *Library of Congress Historic American Engineering Record.*

All that remains of the original massive Patterson Viaduct are its stone bones rotting in the underbrush. *Library of Congress Historic American Engineering Record.*

THE HAUNTING

The legend of the "Blink Man," also known as "Peeping Tom," the "Tunnel Man" and "Ilchester the Molester" goes back at least to the Great Depression. It's said that an old hobo walking through the tunnel around midnight one evening was killed by a speeding train. The violence of his death trapped his spirit in the tunnel. It lurks there, just out of sight, to terrorize visitors brave enough to try to stare him down.

According to the story, if a person stands on the Howard County side of the railroad bridge at exactly 11:00 p.m. and stares into the tunnel without blinking for one full hour, a nightmarish experience will begin.

At the stroke of midnight, the Blink Man will suddenly appear at the far end of the tunnel. But he doesn't stay there. Each time the person blinks after it first appears, the apparition will get closer, and closer, and closer to them. This continues moment after moment, blink after blink. Finally, the Blink Man comes nose to nose with his petrified victim. Then the real horror begins as the person begins to feel the spirit's long, scraggly eyelashes fluttering against their face.

One teller of the tale claims that "these constant butterfly kisses are said to send you into madness, driving you to rip out your own eyes in a fit of blind rage." Other accounts say that victims of the Blink Man's advancing appearance are typically found dead from heart failure—literally scared to death.

The Blink Man phenomenon was described by sixteenth-century alchemist Jakob Bohme as a "Flimmern-Geist," literally translated as a "flicker-ghost or spirit." It's said that these otherworldly beings are spirits of those who die violent deaths and spend eternity just beyond the field of vision of the living. Some theorize that the Ilchester Tunnel is actually some kind of "interdimensional focal point" where the physical world intersects with the spiritual world. They say that prolonged staring at one of these focal points draws these otherwise invisible spirits into the gaze of the viewer—where they materialize and paralyze them.

According to local lore, no one has survived an encounter with the Blink Man. His appearance is said to be the only paranormal experience in Maryland that is associated with actual fatalities. Whether those who have seen him perished in a fit of self-harm, a heart attack or the terrifying crush of an oncoming train is not known for certain. But what is certain is that the Blink Man is always there, waiting just beyond the field of vision of another victim foolish enough to try to stare him down.

HELL HOUSE

THE SINISTER LEGEND OF ST. MARY'S SEMINARY LIVES ON LONG AFTER THE INSTITUTION'S DEMISE.

FEW HAUNTED ELLICOTT CITY SITES are as infamous as old St. Mary's College. Originally called Mount St. Clement and more recently known as "Hell House" and "Creepy College," the massive structure once located at 4446 Bonnie Branch Road stood abandoned for nearly a third of its 140-year history. Although now lost to vandals, fire and a final bulldozing, memories of the historic seminary, along with stories of an insane priest, murdered nuns and satanic rituals continue to haunt the imagination of locals and visitors alike.

THE HISTORY

St. Mary's College was built on a tract of land owned by George Ellicott Jr., a grandson of Andrew Ellicott, one of the founders of Ellicott City. The land was originally the site of a gristmill, ominously known as "Dismal Mill," the first of many structures that would be built along the banks of the Patapsco River. Ellicott added a handsome stone home for himself as well as a tavern at the little village that would come to be known as Ilchester. He envisioned that his town, like Ellicott City just two miles up the river, would grow into a thriving stop for travelers along the B&O Railroad route.

As bad luck would have it, the site Ellicott chose for his venture was located at a particularly steep slope on the railroad line where trains either

had to whiz by or build up a head of steam to get up the hill. Consequently, Ilchester languished, and Ellicott had difficulty trying to find a buyer for the property.

In 1866, shortly before Ellicott's death, the Redemptorist order of the Roman Catholic Church bought 110 acres of the land for $15,000. Father Joseph Firle said the first Mass in Ellicott's stone house in August of that year. Two years later, the fathers spent $80,000 to construct a large, four-story "upper school building" for the young men studying to become priests and their three faculty members. They named the college Mount St. Clement.

In 1872, a frame addition to George Ellicott's stone tavern, known as the "Lower House," was constructed to serve as a "minor seminary" for younger students. A beautiful sixty-six-step stone staircase known as "Jacob's Ladder" originally connected the upper and lower campuses.

The college complex continued to expand over the years. In 1882, the Redemptorists added a chapel dedicated to "Our Mother of Perpetual Help" to the massive cupola-topped building and changed the name of the school to St. Mary's College. In 1934, a fifth floor was added to the seminary that now towered over the Patapsco River valley. Over the years, thousands of young men prepared for the priesthood at St. Mary's College. According

Built in 1868, abandoned in 1972, burned in 1997 and bulldozed in 2006, St. Mary's Seminary/"Hell House" is no more. *Howard County Historical Society.*

to one source, during its heyday, the college graduated classes of as many as 100 to 150 students at a time.

But times changed. In 1958, the parish moved the church to a new facility farther up the hill on Ilchester Road. Over the next decades, enrollment at the college declined. The Lower House burned down in 1968, and in 1972, after graduating its last ten students, the seminary closed.

The huge building remained vacant for the rest of its existence. In 1982, a developer named Michael Nibali bought thirty-three acres of the site, including the college building, for $250,000. He had planned to convert the college into ninety-six apartments. Unfortunately, his grand plans weren't approved, and the abandoned building began to attract vandals.

In 1988, Sateesh Kumar Singh of BCS Limited Partnership purchased the college buildings and property for $400,000 and hired caretaker Alan Rufus Hudson and his vicious pack of Rottweilers to fend off trespassers.

Evidently, Hudson was a very enthusiastic defender of the property and was repeatedly arrested on assault charges over the years. In 1996, he ran off a group of trespassers who later returned with baseball bats. Hudson met them with a shotgun, shooting one of them in the side.

On Halloween night in 1997, the history of St. Mary's College came to a fiery end when arsonists turned the buildings into a towering inferno. Now completely in ruins, the remains of the college continued to attract vandals, graffiti artists and adventurists until 2006, when the bones of St. Mary's College were bulldozed into dust.

The Haunting

The stories began circulating in the late 1980s with tales of teenagers lured to the abandoned buildings in the deep woods, hearing dark whispers of unthinkable things and seeing shadowy figures flickering out of the corners of their eyes.

Slowly, a very disturbing narrative began to emerge. It's said that a priest consumed by the fires of lust that roared to life after decades of self-enforced celibacy raped four nuns over a period of several years at St. Mary's. Terrified to report the clergyman, the nuns kept their secret from their superior until one of them came upon one of their younger sisters sobbing in her sparely furnished room.

After gently questioning the sister as to what was wrong, the girl finally confessed that she, too, had recently been a victim of the rogue priest. Horrified, the nun knew she had to expose the predator.

The archdiocese defrocked the now elderly priest and banished him from St. Mary's. But he did not go quietly. As a pair of fellow priests wrestled him out of the building and down the sixty-six steps of Jacob's Ladder, he vowed to return to exact revenge on his accusers.

Not long after that, a janitor putting away supplies in the subterranean, cavernous basement beneath the seminary came upon a horrifying sight. There, hanging by their necks from the rafters, were all five of the nuns who had been raped. They were hung facing each other in a circle, and at the center of that circle was a satanic pentagram drawn in the victims' blood.

Shocked, the janitor stumbled backward, right into the dead body of the old priest, who had killed himself after his last victim ceased twitching. After that, it's said that something demonic was released at the seminary that continued to roam the halls long after the last seminarian had left and the building was abandoned.

In the years afterward, rumors circulated that members of satanic cults would meet to sacrifice goats whose dried blood was said to stain altars on the second floor of the building. Visitors brave enough to enter the grounds at night reported seeing apparitions of bloody-handed nuns and priests, feeling icy cold spots, hearing strange sounds and discovering disturbing spectral images in photographs they had taken at the site.

The legend of Hell House grew and drew hundreds of thrill-seekers over the years. They were often chased off by the shotgun-wielding caretaker. Today, there's nothing left to guard. The seminary ruins and its supposed altars to demons, as well as everything that ever stood at St. Mary's, is gone. Nothing but memories of what was and nightmares of what might have happened there remains.

SPRING HILL

DISTURBING DISCOVERIES AND A LONG-KEPT SECRET HAUNT THIS LOVELY MANOR HOME.

DRIVERS TRAVELING ALONG MONTGOMERY ROAD near Ellicott City have probably caught a glimpse of this lovely home located down a long driveway guarded by a gate and brick pillars. Hidden within its gracious halls are the origins of its humble beginnings and the dark secrets of a former owner who finally got to tell them.

THE HISTORY

Spring Hill stands on a 1,073-acre land grant that was originally patented in 1695 to Samuel Chew and called "Chew's Resolution Manor." In 1718, he sold the property to Caleb Dorsey Sr. Upon his death in 1742, the land was passed to his son, "Caleb of Belmont." Caleb Dorsey Jr. subsequently gave it to his daughter Rebecca as a gift when she married Captain Charles Ridgely, the builder of Hampton. The property Spring Hill would be built upon became known as "Rebecca's Lot."

Around 1787, Ridgely built a log hunting cabin on the property and added a second one next to it shortly afterward. After Rebecca's and Charles' deaths, the property passed into the hands of their son Charles Ridgely of Hampton, who served as the governor of Maryland from 1815 to 1818.

It's said that Spring Hill's two-and-a-half-story, English-garden-wall and brick-bond manor home was completed around 1820. The earlier hunting

Entombed in two centuries of history, a once-silent spirit at Spring Hill reveals a shocking secret. *Collection of Judith Draper Perrine.*

lodges were shingled over and connected to the manor home, creating a series of rooms used as a library, dining room, pantry and kitchen on the first floor as well as three bedrooms above. The original hunting lodge, now the kitchen, features an enormous stone fireplace that is still in working order today.

The lovely home, along with the stone and frame outbuildings of Spring Hill Quarters, passed into the hands of Mary Pue Ridgely, who had married Charles Samuel Worthington Dorsey. Charles died in 1845, and Mary passed away in 1872. The property then went to their daughter Comfort Worthington Dorsey and is listed on the 1878 Martinet Map as her home. Comfort passed away on December 16, 1893, and left the property to her namesake daughter. The younger Comfort never married and died in 1910 at the age of fifty-two. She was the last Dorsey to live at Spring Hill.

After Comfort's death, Spring Hill was purchased by Garnett Yelverton Clark and his wife, Helen. During Prohibition in the early 1920s, Garnett's older brother Booker was appointed as a "revenue officer" whose job it was to find and destroy stills along with the whiskey. One of his first stops was Spring Hill. There, according to Senator James Clark Jr.'s memoir, he "promptly axed Garnett's barrels of choice whiskey that Garnett had carefully laid in to see him through the drought."

Garnett died young, too. He came down with pneumonia while traveling in Pennsylvania and passed away on December 5, 1928, at the age of fifty-one. After his death, his twenty-four-year-old wife continued to live at Spring Hill with her children Garnett Y. Jr., Ann and Nancy.

Orville Samuel Harris and his wife, Lena Mae, seem to have been the next owners of Spring Hill. In 1946, they sold it to Ellen Wassall Mead and Henry C.A. Mead, a medical doctor from Chicago. In 1953, the Meads sold the property to Paul W. McDonald and Ann Albert McDonald. Paul died in 1966, but his wife stayed on until she sold the property to Wallfried "Ted" Roth and his wife, Helga M. Roth, in 1972.

Born in Germany, Ted Roth was a veterinarian and worked as assistant director at the Maryland Zoo. His wife held a PhD and was employed in the field of disability and rehabilitation. During his years at the zoo, he served under famed director Arthur Watson, who was nearing the end of his career. It's said that Roth, expecting to be named director after Watson retired,

Listed as a member of the Scientific Advisory board for this odd newsletter, Dr. Roth was tapped to investigate the sighting of the "Sykesville Monster" in 1973. *Shelley Davies Wygant.*

What happened in the previously undiscovered attic room that couldn't bear the light of day? *Jeffrey Wygant.*

became despondent when he learned that Stephen H. Graham would be taking over instead. On December 1, 1977, Roth climbed the winding staircase of the manor home to an upstairs bedroom and supposedly shot himself in the head.

The house went up for sale and stayed on the market for almost a year. Ultimately, it was purchased by John H. Burchett and Judith A. Draper on November 29, 1978. When the couple took possession, the home had obviously stood empty for quite some time. The kitchen cupboards were filled with mouse nests, and the house had fallen into disrepair.

But mouse nests weren't the only disturbing things the couple found. During the course of exploring the house, they found old black-and-white photographs of women holding skulls that had snakes weaving in and out of their empty eye sockets. As unnerving as that discovery was, it paled in comparison to what they found next.

When they climbed to the top of the winding staircase, they opened a door to an attic room on the third floor that was probably once used as servants' quarters. Looking around, they noticed a small ell at the back of the room and a small door.

Intrigued, they opened the door and peered into a space that was

Remains of the blackout paint that once blocked all light from Spring Hill's secret room can still be seen today. *Jeffrey Wygant.*

shrouded in total darkness. Turning on their flashlights, they could see three small wooden steps that led down into the inky blackness of a room. Gingerly, they made their way into what their flashlights revealed to be an unfinished room with exposed brick walls and a relatively high vaulted ceiling at the peak of the roofline. As surprising as the discovery of the room was, one feature of this hideaway shocked them even more. They saw that a set of windows that should have been lighting the room had been totally blacked out with paint. A slow horror dawned on them as they realized that this secret room was located directly above the bedroom where Roth was said to have killed himself.

Over the next decades, Judith Draper, who bought out Burchett's half of the home, gave little thought to Dr. Roth and the hidden room except to relate the tale to mesmerized guests at dinner parties.

In 2012, she built a substantial addition to the home that includes a large master suite, additional bedrooms, a powder room, a pantry, a garage and an in-law apartment that can be reached by an elevator that serves all three floors. She continues to live there with her husband, Randall Perrine, and says that, except for one terrifying night in 2009, she's never witnessed anything supernatural going on in the house.

THE HAUNTING

Said to be one of the county's most prominent haunted houses, Spring Hill's oldest ghosts seem to be party people. Visitors sleeping above the manor's main parlor have reported being awakened in the middle of the night by the murmuring sounds of guests mingling and "the lilting serenades of a harpsichord" in the rooms below.

One of the owners claimed she occasionally felt the presence of these unseen guests brush against her when she went to investigate the sounds, which were replaced by a "disturbing sort of stillness" when she entered the room.

The ghostly music is attributed to the Dorsey sisters, Mary and Comfort, who are said to have delighted visitors with impromptu concerts. Others have seen an apparition of a gentleman dressed in formal nineteenth-century clothes. He's believed to be Comfort Dorsey's fiancé, who was killed in a hunting accident, leaving her to die a spinster at the home.

Visitors to Spring Hill have also reported feeling uneasy in the upstairs bedroom where Dr. Roth was said to have killed himself and where objects have mysteriously vanished and reappeared in another part of the room.

Although the current owners never experienced anything themselves, in 2009, these stories prompted the Howard County Historical Society to offer a paranormal investigation as a silent auction prize. The owner, Judy Draper Perrine, was the high bidder. She invited a group of friends to join her and local paranormal investigator Beverly Litsinger for an evening of what would presumably be lighthearted fun. What happened was anything but.

After dinner, the investigator handed out various pieces of ghost-detecting equipment that were supposed to light up or buzz if a ghost was present.

Guests were told that if they detected a ghost, they should introduce themselves before asking any questions. They spent the better part of an hour in the downstairs parlor, library, dining room and kitchen area introducing themselves to spirits.

The investigator wasn't told about the possibly haunted upstairs bedroom. The thinking was that if there was indeed a presence there, she would find it. If not, then the evening was just all in good fun.

The group climbed the stairs and began exploring the master bedroom, getting a few hits here and there. When they were finished, the investigator walked down a few steps into the center bedroom and asked if a spirit was present. That's when all hell broke loose.

Everyone's detector lit up and began blinking and buzzing. Eyes widened and gasps went up as Litsinger questioned the ghost, getting loud confirmation from the sensors on some things and silence on others.

Since the investigator had "found" the ghost, the owner decided to reveal that this was the room in which the previous owner, Dr. Roth, was said to have killed himself. Answers to additional questions seemed to establish that the spirit was indeed the departed doctor.

When asked "Did you kill yourself?" in the room where it's said Dr. Roth died, his ghost replied with an unexpected answer. *Jeffrey Wygant.*

The guests were riveted by what had begun in fun but had turned into an actual paranormal experience. Whether they were believers or skeptics, they could have never imagined what happened next.

In wrapping up, Litsinger asked the spirit—who had remained silent for more than thirty years—a question that everybody thought they already knew the answer to.

"Did you kill yourself?" she asked the spirit.

The reply was total silence and darkness from the detectors.

She then asked, "Did someone kill you?"

The room erupted in a blaze of blinking lights and buzzing. Stunned, the guests hurriedly exited the room and ran down the steps to the parlor below, leaving Litsinger to continue her discussion with the ghost.

When she joined them, the investigator didn't have more information about the identity of the possible murderer, but she did have digital photographs of the room on her camera that showed a host of "orbs" filled with what looked like tiny eyes.

At that point, the shaken guests were more than ready to go home. But the investigator stopped them. Before she would let the guests leave, she asked everyone to join her in a prayer that asked whatever and whoever they had encountered that night to remain there and not follow them home.

They didn't have to be asked twice. Everyone hurriedly said the prayer, grabbed their coats and fled, leaving the owners and whatever had been awakened at Spring Hill that night in the quiet of their not-so-empty house.

Why had the spirit of Dr. Roth waited so long to make himself—and the shocking circumstances of his death—known? If he was indeed murdered, who did it? There was no police investigation, and his death was widely reported as a suicide. Perhaps whatever black arts he practiced in the secret room on the third floor had summoned some demon within him who forced the revolver to his head that night—and added yet another ghost to the crowd of spirits that haunt Spring Hill.

BIBLIOGRAPHY

Books

Arnold, Melissa. *The Hauntings of Ellicott Mills*. Ellicott City, MD: Inch-By-Inch Enterprises, 1998.

Back, Mollie, and Brian Wolle. *Ghost Encounters: Tales of the Supernatural Residents of Historic Ellicott City*. Gettysburg, PA: Unicorn Press, 1998.

Blank, Trevor J., and David J. Puglia. *Maryland Legends: Folklore from the Old Line State*. Charleston, SC: The History Press, 2014

Cramm, Joetta M. *Historic Ellicott City: A Walking Tour*. Woodbine, MD: K&D Limited, 1996.

————. *A Pictorial History of Howard County*. Norfolk, VA: Donning, 1987.

Feaga, Barbara W. *Howard's Roads to the Past*. Ellicott City, MD: Howard County Sesquicentennial Celebration Committee, 2001.

Holland, Celia M. *Old Homes and Families of Howard County, Maryland*. Self-published, 1987.

————, Janet P. Kusterer and Charlotte T. Holland. *Ellicott City, Mill Town, U.S.A.* Ellicott City, MD: Historic Ellicott City, 2003.

Howard County Historical Society. Images of America: *Howard County*. Charleston, SC: Arcadia Publishing, 2011.

Kusterer, Janet, and Victoria Goeller. *Remembering Ellicott City: Stories from the Patapsco River Valley*. Charleston, SC: The History Press, 2009.

————. *Then & Now: Ellicott City*. Charleston, SC: Arcadia Publishing, 2006.

Lake, Matt. *Weird Maryland: Your Travel Guide to Maryland's Local Legends and Best Kept Secrets*. New York: Sterling Publishing, 2006.

Mitchell, Richard F. *Standing on a Hill: The History of St. Peter's Church, 1842–1992*. Ellicott City, MD: Richard F. Mitchell, 1993.

Mylander, Allison Ellicott. *The Ellicotts: Striving for a Holy Community*. Ellicott City, MD: Historic Ellicott City, 1991.

Newman, Harry Wright. *Anne Arundel Gentry: A Genealogical History of Some Early Families of Anne Arundel County, Maryland*. Vol. 2. Westminster, MD: Family Line Publications, 1991.

Noratel, Russ. *Ghosts of Ellicott City*. Harpers Ferry, WV: Cosmic Pantheon Press, 2012.

Okonowicz, Ed. *Haunted Maryland: Ghosts and Strange Phenomena of the Old Line State*. Mechanicsburg, PA: Stackpole Books, 2007.

Sharp, Henry K. *The Patapsco River Valley, Cradle of the Industrial Revolution in Maryland*. Baltimore: Maryland Historical Society, 2001.

The *Times* Newspapers. *The Flood of 1972*. Ellicott City: Times Newspapers and Allied Graphics of Ellicott City, Maryland, 1972.

Toomey, Daniel Carroll. *The Patapsco Guards: Independent Company of Maryland Volunteer Infantry*. Baltimore, MD: Toomey Press, 1993.

Varhola, Michael J., and Michael H. Varhola. *Ghost Hunting Maryland*. Cincinnati, OH: Clerisy Press, 2009.

Wise, Marsha Wight. Images of America: *Ellicott City*. Charleston, SC: Arcadia Publishing, 2006.

Selected Online Sources

Eastern Entities. http://easternentities.com/hauntedplaces/Maryland/howardcounty/ellicottcity/lilburn.html.

Elkridge Heritage Society. http://www.elkridgeheritage.org/collection/collection-research-index-to-land-patents.

A Few Odd Moments in Howard County. https://www.youtube.com/watch?v=GCC2zInm31Q&list=PLjYho6X6eg07yywveLiAwAlcYNcm9MOtR&index=9&t=0s.

Ghosts of The Prairie: Haunted Ellicott City. http://www.prairieghosts.com/hauntelcity.html.

Haunted Houses.com. http://www.hauntedhouses.com/states/md/lilburn.htm.

Haunted Places in Ellicott City, Maryland. http://www.hauntedplaces.org/ellicott-city-md.

Hauntworld.com. https://www.hauntworld.com/haunted-houses.

Historic American Buildings Survey. http://www.loc.gov/pictures/collection/hh.

Historic American Engineering Survey. http://www.loc.gov/pictures/collection/hh.

JHBL Family Genealogy. http://latrobefamily.com/genealogy/getperson.php?personID=I3243&tree=mytree.

Maryland Department of Assessments & Taxation. https://sdat.dat.maryland.gov/RealProperty/Pages/default.aspx.

The Maryland Inventory of Historic Properties (MIHP). https://mht.maryland.gov/research_mihp.shtml.

MDLANDREC. https://mdlandrec.net/main.

True Hauntings of America. http://hauntsofamerica.blogspot.com/2007/10/haunting-of-lilburn-mansion.html.

Selected Online Articles

Carson, Larry. "Ellicott City's Cacao Lane Occupies 3 Stone Houses that Date 1834." *Baltimore Sun*, October 28, 1999. http://articles.baltimoresun.com/1999-10-28/news/9910280045_1_cacao-parsons-lane-restaurant.

Chagnon, Renee. "Hardware Business Surpasses 170 Years of Service." *Hardware Retailing*, July 25, 2016 http://www.hardwareretailing.com/hardware-business-170-years.

Higgins, Mallory. "Peeping Tom: The Flickergeist of Ilchester Tunnel." *Ellicott City Patch*, November 23, 2016. https://patch.com/maryland/ellicottcity/peeping-tom-flickergeist-ilchester-tunnel.

Ireraci, Ron, "Lilburn: Ellicott City's Haunted History House." *Pennsylvania Haunts & History*. September 2012. http://hauntsandhistory.blogspot.com/2012/09/lilburn-ellicott-citys-haunted-history.html.

JackMc. "Hazelhurst Manor (Lilburn Mansion)—Ellicott City." *Mid Atlantic Hauntings and Ghosts*, October 2, 2011. http://mid-atlantichauntings.blogspot.com/2011/10/hazelhurst-manor-lilburn-mansion.html.

L, Beverly. "History of Hell House, Ellicott City, Maryland." *Haunted USA*. http://www.hauntedusa.org/beverly.htm.

Powder, Jackie. "For Sale: 7-BR Mansion, Ghosts Included Historic House Is Local 'Showcase'." *Baltimore Sun*, August 23, 1993. http://articles.baltimoresun.com/1993-08-23/news/1993235048_1_lilburn-hazlehurst-ellicott.

Reber, Patricia Bixler. "Ann Tonge and Tonge Row." *Forgotten History of Ellicott City & Howard County*, March 27, 2017. http://historichomeshowardcounty.blogspot.com/2017/03/ann-tonge-and-tonge-row.html.

Ghost Tours

Howard County Tourism & Promotion/Howard County Historical Society. Ye Haunted History of Olde Ellicott City Ghost Tour Parts I & II.

ABOUT THE AUTHOR

CREATIVE DIRECTOR AND MARKETING EXECUTIVE Shelley Davies Wygant is a past president, officer and board member of the Howard County Historical Society and Historic Ellicott City, Inc. In addition to this book, she is the author of Images of America: *Howard County* and owner of Haunted Ellicott City LLC, a resource for all things spooky in this eighteenth-century mill town. She lives with her husband, Jeffrey, two dogs and four chickens in one of the few historic homes in Ellicott City that isn't haunted.

Visit us at
www.historypress.com